What people are about

The Animatic

At once theoretically dazzling and fearless, *The Animatic Apparatus* shows how the production of life in animation deconstructs ontology as such: "There is no death in animation, because there is no being — no existence — to begin with." But an-ontology is not the end of living. Instead, carefully tracing how the medium of animation has come to operate as a supermedium, Levitt finds animation to be the key not only to modelling the contemporary condition but also to formulating an ethical relation to it. Animation offers nothing less than a toolkit for new assembling of lives upon the active void of contemporary media.

Thomas Lamarre, author of *The Anime Machine: A Media Theory of Animation*. Professor of East Asian Studies and Communication Studies, McGill University, Montreal

With subtlety and élan, Levitt compellingly animates an historical journey with dolls, puppets, automata, replicants and artificial life to secure the case for "an-ontology." Media, in the form of novels, films, images, cartoons, screens, robots, and other automata are recursively part of the "human" condition such that distinctions between life and artificial life or intelligence and AI are ultimately unsustainable. Levitt's inspired pursuit of a mediology of technology and metaphysics demonstrates that whatever we are, our emergence is bound up with the simulacrum, and that animation is at least as real as the real itself. What's more, our ethics and our politics must come from that condition.

Jonathan Beller, author of *The Cinematic Mode of Production: Attention Economy and the Society of the Spectacle*. Professor of

Humanities and Media Studies and Critical and Visual Studies, Pratt Institute, Brooklyn, NY

What if Mamoru Oshii's 2004 anime *Ghost in the Shell 2: Innocence* is not just a midnight cult film, but the secret template for nearly all of 21st century technoculture? In *The Animatic Apparatus*, Deborah Levitt convincingly argues that this is actually the case. "Images possess their own forms of vitality," ones that cannot be easily distinguished from our own.

Steven Shaviro, DeRoy Professor of English at Wayne State University. His books include *Connected, or What It Means to Live in the Network Society* (2003), *Post-Cinematic Affect* (2010), and *The Universe of Things* (2014)

The Animatic Apparatus

Animation, Vitality, and the Futures of the Image

The Animatic Apparatus

Animation, Vitality, and the Futures of the Image

Deborah Levitt

Winchester, UK
Washington, USA

First published by Zero Books, 2018
Zero Books is an imprint of John Hunt Publishing Ltd., Laurel House, Station Approach,
Alresford, Hants, SO24 9JH, UK
office1@jhpbooks.net
www.johnhuntpublishing.com
www.zero-books.net

For distributor details and how to order please visit the 'Ordering' section on our website.

Text copyright: Deborah Levitt 2017
Cover image: Gabriella Nicole Padilla

ISBN: 978 1 78099 269 3
978 1 78535 703 9 (ebook)
Library of Congress Control Number: 2017934036

A CIP catalogue record for this book is available from the British Library.

Design: Stuart Davies

Printed and bound by CPI Group (UK) Ltd, Croydon, CR0 4YY, UK

We operate a distinctive and ethical publishing philosophy in
all areas of our business, from our global network of authors to
production and worldwide distribution.

Contents

Acknowledgements

To the multitude of creatures, great and small, who have aided and abetted the writing of this book: You have shared your inspiration and support, your brilliant ideas and incisive critique, your energy and warmth, your times and spaces, your love and wonder. While there are far too many of you to list here, most of you know who you are. Thank you.

Introduction

The emergence of animation as the dominant medium of our time coincides with novel developments in the biological sciences that open possibilities for producing living beings, as well as with mutations in those discourses and practices around life currently framed as "biopolitics." The coalescence of these transformations marks our cultural moment: While at first these might appear as disjunct cultural fields with no causal and little conceptual relation, understanding the link between Dolly the cloned sheep and her progeny (metaphorically speaking) and

the multimedial bodies of *Avatar* is a key to understanding the time in which we live. Today, the horizon of possibilities of simulation in both art and science—from cartoons and the animatic effects of CGI to the various dreamt and incarnate potentials of biological production—are shifting the reigning cultural paradigms of life in significant ways, moving away from questions about ontology, category, and being to ones of appearance, metamorphosis, and affect. I call our time the age of the animatic apparatus.

Despite the more apparently radical specter of, for example, a cloned human being, the most important sites for transformations in concepts and practices of life are to be found in our more everyday experiences, in, for example, our ingestions of pharmaceuticals of all kinds and our auto-monitoring of our vital statistics with phones, watches, and fitness trackers. In particular, it is at the spectator-screen nexus, at the site of our interactions with images, that we can see many of the crucial dimensions of this shift take place. And as I've already begun to suggest, the rise of animation and simulation, that is, their move from the margins to the very center of cultural production, has produced a key dimension of this shift, releasing images from actual and perceived ties to a real world as living bodies are increasingly untethered from determinations of biological vocation or destiny.

In this book, I address these two characteristics of the contemporary moment—one revolving around transformations in the status of images and the other around transformations in the status of "life," that is, in how we conceive, experience, and produce forms of vitality. These two are mutually intertwined. In fact, each can be properly seen only when viewed in relation with the other.

Life Image

A glance at the news on almost any given day leaves little doubt

that we live now in a culture obsessed with the terms of life. From debates around abortion and euthanasia to cloning and the patenting of living organisms, the status and limits of life are everywhere at issue. In a much-quoted statement, Giorgio Agamben remarks that the concept, life, "never gets defined as such," but that "everything happens as if, in our culture, life were what cannot be defined, yet, precisely for this reason, must be ceaselessly articulated and divided" (Agamben 2004, 13). Defined, articulated, divided—but also, as we will see, produced, reproduced, engineered, made.

What I will investigate here is what we might call the mediology of life and the life of media,[1] that is, how new forms of life and modes of vitality emerge at the spectator-screen intersection as this transforms over time. I will engage the questions raised through the life-image nexus via the concepts of animation and the animatic apparatus. The noun forms of "life" and "animation" are close to synonymous. But the verb forms have different connotations. While to live means to be alive or to have life, to animate means to endow with life; it refers to a process of making vital. On one hand, it may mean in a literal sense "to give life to," "vivify," "quicken." On the other, it may mean to represent as alive, to give the appearance or illusion of life. While these definitions of animation have conventionally been regarded as separate, with the first associated most closely with the natural world and the second with art, there's always been a kind of slipperiness that haunts the usage of the term, a slippage from art to life and back again. In the animatic apparatus, however, these converge, as life becomes not a property that one has, or doesn't, but a site for intervention, production, *poiesis*.

Mamoru Oshii's 2004 anime film, *Innocence: Ghost in the Shell 2*, indexes these changes. It is a kind of philosophical treatise on the animatic apparatus—on the ways of the animate and the inanimate; on the modes of humans, machines, and animals; on the historical discourses on the mechanical and the vital. Set

3

in 2032, in a world where variously modified humans interact with cyborgs and fully artificial entities, the plot unfolds as an action-genre narrative in which an elite anti-cyber terrorism unit investigates a series of mysterious deaths: High-tech sex dolls are going berserk, killing first their owners and then themselves. While the plot is interesting for the manner in which it reconfigures some of the now conventional tropes of the science fiction narrative, what is special about this work is its intervention into rethinking artificial life and its development of an animatic aesthetics that privileges affect—that is, subtle forms of visceral and emotional response—over both narrative and representation.

Innocence is a kind of anti-Pinocchio tale. Its artificial creatures don't want to become real girls and boys. They don't want to be real, and they certainly don't want to be human. The film stages a critique of anthropocentric humanism and ontological hierarchy. In fact, it consistently points to the an-ontology of the animatic apparatus. It is never about models and copies, but rather about simulacra that open new territories of feeling and thought.

Automata, puppets, dolls, cyborgs—all artifacts of a kind of artificed life—are central both to the history of thinking artificial life and to my analysis of animatic forms of life here. In this book, I use Oshii's film—along with various other texts and cultural phenomena from Heinrich von Kleist's 1811 romantic tale, "On the Marionette Theater," to celebrity plastic surgeries—as a machine for thinking the contemporary moment and the transformations that occur in between life and images. An important feature of what follows is the interplay between the concept of the animatic apparatus as a *dispositif*, that is, as a kind of organizing mechanics for contemporary culture, and the notion of an animatic apparatus as it pertains to (a very broadly conceived version of) moving-image animation. This swerve back and forth across scales and senses of animation

provides important insights into our contemporary *Umwelten,* our life worlds, and into the qualitative difference of our cultural moment, those tendencies whose critical mass engenders a change in kind and not merely in degree. I call the methodology of this work "media ethology." In its basic form, ethology is a subdiscipline of biology. It is the science of animal behavior. It focuses on what animals do, on how they act. Ethologists will often look at a particular behavior and analyze its function across various species, rather than focusing on a single species. We can say that ethology is an inquiry into the *how*—rather than the *who*—of things. Jakob von Uexküll, an ethologist of the early twentieth century, looked at how species' perceptual systems interact with their environments to produce very different kinds of *Umwelten*—lifeworlds—in each case. A key feature of this formulation is that perception and world are co-constitutive. Here, I am concerned with encounter between the human perceptual system and its media environment at particular moments in time—and with the kinds of selves, lives, and worlds that are produced in this conjunction. But of course, this is not a work of biological anthropology or cognitive science or perhaps even of media studies, *strictu sensu.*[2] My focus here is on the interactions among the material structures of moving-image production, the always changing human perceptual apparatus, and the set of cultural assumptions and epistemologies that frame and structure the modes of experience and forms of life generated at the intersection of materialities of communication and perception. In other words, media ethology is a consideration of how we make sense (meaning) of sense (sensation) as these emerge together—and constitute one another—at the spectator-screen nexus. While inextricably bound to material structures of both media and perception, this nexus is as much a phantasmatic—even a hallucinatory— domain as a material one. And it is precisely here that we find new forms of life and modes of vitality emerging.

5

Chapter 1

The Cinematic Regime: Biopolitics, Spectral Life, and the Crisis of Ontology

In 1895, the first cinema cameras — the US Vitascope, the German Bioscope, and the English Animatograph — were produced and patented almost simultaneously. The names of these new inventions made a powerful claim: the cinema will capture, or produce, life itself. But this cinematic mode of life is not confined to the movie theater. The world of the twentieth century is shaped by the spectral-spectacular life/death of the cinematic image. In this chapter, I will sketch out some of the central features of this regime of life so that, farther on, we will be able to closely track the transformations from the cinematic regime to the animatic apparatus.

As the new medium is born, so is a new kind of body with new senses of liveliness. These are the twinned and intertwined axes of the cinematic regime of production — as well as of the twentieth-century management of the human body theorized under the rubric of "biopolitics." The new medium is likewise linked with what we might call the cinematic "reality function," that is, the means through which at least much of twentieth-century film and film theory understands itself as existing, if complexly, in relation to what is commonly referred to as a "pro-filmic real." Finally, as Louis-Georges Schwartz remarks, this twentieth-century cinematic spectrality casts the philosopheme life/death into an undecidable, aporetic relation. Its liveliness is always ambivalent, oscillating, haunted. The cinematic regime operates in and as a kind of crisis in ontology.

As Giorgio Agamben describes it, we can see cinema as a kind of "eye" with a very particular relation to the living, human body (Agamben 2000, 50). Cinema, as I discuss it here, is a way

6

of seeing, a form of technological vision that extends beyond the material production and spectatorship of films. It structures a way of seeing and a way of understanding visuality and its objects. It also produces a new understanding of living bodies; we can say, even, that it creates them.

A New Kind of Body

One of the cinema's most important technical precursors, the chronophotographic camera, was developed as a means to study the living body. The "chronophotographic gun" was a scientific imaging device developed by Etienne-Jules Marey that played a central role in the emerging discipline of physiology. Marey's object of study was animal motion. His camera captured twelve consecutive frames per second and displayed the images on a single plate. The task of this apparatus was to transcend the speed of the human eye in order to see the body in ways that human perception could not. It was able to break down bodily movement into its hitherto invisible constituent parts, making the living body available to study and analysis. Marey's chronophotographs showed the micro-movements involved in running, in jumping, in a successful—or failed—pole vault. It could analyze the gait of soldiers.[1]

There's a story about Marey's more famous contemporary, Eadweard Muybridge, whose photographs of horses running and women disrobing often grace the opening pages of film history textbooks, that illustrates the capacities and uses of these then-new high-speed imaging devices. Leland Stanford, the horse-owning former governor of California, wanted to settle a famous question about horses' gaits while trotting and galloping. The common consensus and the model for artists' depictions of horses held that horses always maintain one foot on the ground at a trot, while at a gallop, on the contrary, all four hooves leave the ground at once, with the horse's front legs stretching forward and its back legs stretched back. Muybridge

used his own version of chronophotography to disprove both of these beliefs, beliefs incarnated for centuries in paintings and sculptures. Horses are in fact airborne while trotting, as they are at a gallop. In their galloping stride, all four legs leave the ground as they are drawn up under the horses' bodies, not as they stretch forward and back.

High-speed imaging overcame the limitations of the human eye to produce these renderings of horses' bodies in motion. From one perspective, cinema, because of its abilities to slow down and speed up the world, often has been seen as a kind of revelation machine, illuminating a previously unseen world. From another perspective, however, one stressed in the pioneering work of visual studies, the cinematic apparatus and its companions create a new world, one where the human body can appear at extra-human scales and speeds.

In the final chapter of Foucault's *History of Sexuality, Volume 1*, "Right of Death and Power Over Life," he describes the transformations in mechanisms of power that enable the development of the modern biopolitical state. Before the classical age, the form of sovereign power that "was formulated as the 'power of life and death'" was essentially deductive power, "in reality the right to *take* life or *let* live. Its symbol, after all, was the sword" (Foucault 1978, 137). This began to change in the seventeenth century, and by the end of the nineteenth century, the deductive power of the right to take life became just one part of a set of powers designed to "incite, reinforce, control, monitor, optimize, and organize" the vital forces of a population (137). "Now it is over life, throughout its unfolding," Foucault writes, "that power establishes its dominion" (138). Public health and housing initiatives, for example, protect and optimize the vital forces of states' populations with one hand and set up systems for surveilling, monitoring, and controlling them with the other. Once the management and optimization of forces of life becomes the political object *par excellence*, life also becomes the material

for cultural and technological production of all kinds.

One of Marey's students proclaimed that Marey was not so much a scientist as "an engineer of life" (Rabinbach 1990, 90), and as we've begun to see, his chronophotographs have a proscriptive as well as descriptive function. A 1914 article in *Scientific American*, "The Human Body in Action," presents a very telling example:

> It is perfectly apparent that from pictures such as [these], the athlete can learn much. He sees at once at what particular point of a movement he assumed an incorrect position, and why it is that he runs, walks, leaps, or fences inefficiently. At the Joinville School [a military training school in Joinville, France], they are used to record and register the physical conformation and development of the pupils before, during and after training. The studies thus obtained are applied in choosing and instructing the gymnastic staff of the French army.

Athletes see their bodies differently than they would in life, in a painting, or in a mirror. They see them from outside the possibilities of the human body itself, as objects of machine vision. They learn from this machine-produced body, incorporating its techniques into their own. Or, in this example as in many others, the institution (the Joinville School, the French Army) disciplines and administers these techno-bodies to their own particular ends.

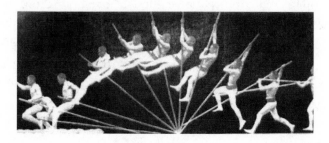

These methods perhaps find their most famous incarnation in the "scientific management" inaugurated by Frederick Winslow Taylor's industrial efficiency and productivity analyses of just a few decades later. Taylor's method attempted to discover, through photographic and filmic analysis, any individual expressivity contained in the gestures of factory workers and to excise it in favor of perfectly homogeneous and efficient gestures synchronized with the movements of machines. The study and management of corporeal practices thus are carried out through images; images are used to reprogram bodies. While Foucault himself never engaged biopolitics' entanglements with modern media, these images and associated practices are implicated in the biopolitical management of life. By the twentieth century, a "culture of life" emerges that produces and is produced by modern media.

Reel Life

With the Lumière brothers' synthesis and projection of images with their Cinématographe in 1895, the analytic sequence of bodily gestures returned as a form of spectral life. It would be almost impossible to overstate cinema's mutual imbrication with both popular and theoretical discourses of life—as well as practices of liveliness—across the twentieth century. In its early years, it was often referred to as "living photography." In 1896, the English version of a program that accompanies a screening of the Lumière brothers' films proclaims: "The interval during which one picture is substituted for a succeeding one is so infinitesimal that, the retina of the eye preserving one image until the next one takes its place, an effect of absolute continuity and perfect illusion of life is obtained" (Cholodenko 2000, 20). In 1926, film theorist Terry Ramsaye wrote that the cinema is "like the tree, clearly an organism, following organic law in its development," (Ramsaye 1926, xxxviii) while numerous other commentators reflected on cinema's uncanny ability to revivify

the dead.

While early cinema's zoetropic monikers would be eclipsed by the term cinema's emphasis on movement, its interior preoccupations with—and productions of—its own particular liveliness continue unabated. In 1960, Siegfried Kracauer claimed that:

> Due to the continuous influx of psychophysical correspondences thus aroused [by films, and more precisely, "cinematic films"], they suggest a reality which may fittingly be called "life." This term as used here denotes a kind of life which is still intimately connected, as if by an umbilical cord, with the material phenomena from which its emotional and intellectual contents emerge (Kracauer 1997, 71).

These entries into cinema's life discourses diverge in important ways. The Lumière film program celebrated the wondrous technology of cinema and its transcendence of human capacities to produce the *illusion* of life. Ramsaye departed from the emphasis on representation to assert that cinema is itself an organic, evolving being. Kracauer's suggestion that spectator, film, and material world are connected by an "umbilical cord" conjures an organic, symbiotic, nurturing relay. Here, "psychophysical correspondences" convey "emotional and intellectual contents" through the physical, material connections between life and cinema. Cinema is composed of and transmits vitality effects and affects.[2]

As I discuss in more detail elsewhere, the gesture that is fragmented and analyzed in the physiology lab is returned in its spectral form in the movie theater. If the poles of cinematic life are the gestural fragment and the spectral survival of the image, the latter screens (in both senses) the former, encrypting the productive, biopolitical dimensions of cinema in the discourse of reflection, representation, and reality. In other words, the same

11

set of techniques that open up a new kind of access to corporeal management and optimization for science, medicine, industry, and government also produce the luminous, larger-than-life bodies of the cinema. These two poles of the biopolitical-cinematic body subtend cinematic life, but the latter tend to occult the former. And the living human body is for the most part—even in abstract film and body horror, where it persists as absent referent or object to be transgressed—preserved or conserved as an autonomous, massy anatomical entity in an anthropocentric world, even where light, the machine, and an analytic eye intervene in its "revelation."

To emphasize this point about the twentieth century's sense of living bodies, even where Marey's images dove down below the full body of the organism—he developed a technique of graphic inscription which led to his invention of the cardiograph (with Auguste Chauveau in 1865), the pneumograph for respiration, and the myograph for nerve and muscle action—it was in the interest of imaging the mobility of what could hitherto only be viewed in immobility. He could explore bodies in living motion (rather than through studies of cadavers). His goal, that is, was to image what he described as "the functions of life, that is to say the play of the organs which anatomy has disclosed to us" (Marey 1868, 280). The functions of life are linked to a vision of the human body as an autonomous organism, as are the techniques he prescribes for the body's improvements. Life was a key term for Marey, and it is precisely this version of life—developed in Marey's physiology lab and becoming spectral in the films that the Lumière brothers and Georges Melies would make just a few years later—that no longer possesses the requisite stability to be the subject of representation, no longer may act as referent in the sense that Marey deploys it here.

Life, Death, and Ontological Crisis

Let's now look more closely at this spectral-spectacular cinematic

life. There's a very striking — and instructive — moment in Fellini's 1987 *Intervista*. Two aging movie stars, Marcello Mastroianni and Anita Ekberg, watch themselves in another Fellini film, *La Dolce Vita*, a film made twenty-seven years earlier. In *La Dolce Vita*, these two play almost impossibly beautiful people — she, a statuesque and voluptuous blonde, he, tall, dark, and handsome in an impeccably tailored mod suit — who are also paragons of the exploding global media spectacle circa 1960. She is an American screen goddess and he a celebrity gossip writer. (Marcello's colleague and sometime sidekick in the film, Paparazzo, will lend his name to the emerging "profession".) In the sequence they watch, a now hyper-iconic scene shot in the Trevi Fountain in Rome, they dance, talk, and kiss as dawn breaks. Watching these spectral images of their youthful selves, Marcello wistfully tilts his head; Anita wipes a tear from the corner of her eye — carefully, so as not to smudge her elaborate makeup.

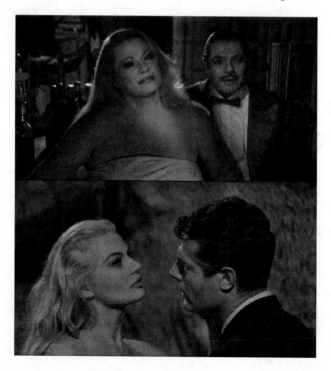

This scene is Fellini's own nostalgic, elegiac, look back at his own career, but it is also a profound reflection on the cultural significance of the cinematic apparatus itself, and particularly its very special relation to time, life, and death. As Fellini's scene presents it, as a luminous, indexical inscription of a pro-filmic real, cinema's projected images and sounds revivify the world as it returns what has passed, and what has passed, along with the dead, always haunts the time-space of cinema's projected present.[3] If, as Vivian Sobchack so aptly suggests, cinema is a form of cosmetic surgery — "its fantasies, its makeup, and its digital effects able to 'fix' (in the doubled sense of repair and stasis) and to fetishize and to reproduce faces and time as both 'unreel' in front of us" — it is, like its surgical counterpart, also always shadowed by its own undoing, haunted by the specter of temporality and decay (Sobchack 2012, 50).

The scene plays out across a series of layered topoi involving embodiment, temporality, reality — and a particular conception of life. To begin with, it is packed with bodies: If, as Sobchack details in a different context, a star actor always has at least four bodies, even in a single role — a no-body-in-particular, a personal body, a character body, and a star body — in this scenario, the bodies proliferate as we try to sort out the confrontations between them.[4] To take Anita as our exemplar, four current bodies confront not just one but four former selves, and each confrontation is slightly different. She is nobody in particular looking across time at this revivification of a youthful body. At the same time she is the private person, Anita Ekberg, looking at a younger version of her personally identified self. She is also a character in one film looking at a character in another, an aging actress watching a young one in a now-iconic film, and an aging actress looking at herself not only as a young actress, but as a young star actress playing the ur-type of the screen goddess.

In this relay of bodies, the older one cries from nostalgia for youth or dismay at age (or both), and the "real" body — despite its

visual and visceral presence—is so overdetermined as to almost collapse under the combined weight(lessness) of the spectacle's spectral bodies. It's a story of time's passing. Its pathos comes from the pathos of aging itself, with its implication of the inevitability of death, from the particularity of this "tragedy" for the female body, the movie star, and the female star even more particularly, but also from the relationship between the "real" and the cinematic body—the former's subjection to the vagaries of time, decay, and death only amplified by the latter's silvery, luminous vitality. (I'm going to bracket the relevance of the shift from the cinematic to the animatic regime to issues of gender and sexuality here, but I will return to address it in Chapter 7.)

This pathos of temporal unfolding, of the interplay between "real" life and death and a spectral life that lives on, also implies Fellini's—or the film's—understanding of the film's own body as an index. That is, it understands itself as a material inscription of a real-life situation that, at a particular time and place, appeared in front of a camera's lens. (One classic example of indexicality is the footprint. In this example, we can see clearly the type of relationship between the image and its referent that this term denotes. The image is produced through a moment of contact. Its referent, the foot, touches a sensitive surface and makes an impression. Where film is discussed as indexical, its moment of contact—the light from a real-world situation hitting a photosensitive surface—is emphasized.) The sense of cinema as an index of the real is essential to this scene's argument, but it's also important to note that the reality effect of the photographic index is not at all figured here as part of a discourse on cinematic realism *tout court*. *Intervista* is about Cinecittá (the famous film studio in Rome, the center of Italian cinema) and about the cinematic dream factory more generally. Throughout the work, we see films in their production processes, the mechanisms of their creation—sets, lights, casts, and crews—exposed to the spectatorial eye. It also casts cinema as a kind of magic.

In the sequence under discussion, Mastroianni, appearing as "Mandrake the Magician," conjures the screen on which the old images appear with a magic wand. The film thus makes an argument about the reality effect of the index in its relations to human life and temporality—without, as I've suggested, casting the image as an unproblematic, veridical reproduction of a real world.

Many film theorists, perhaps most notably Kracauer, André Bazin, and Stanley Cavell, have made the indexical materiality of film central to their understandings of what it is and does, its raison d'être, its vocation. A countertradition has also flourished: In 1938, Rudolph Arnheim wrote that "film will be able to reach the heights of the other arts when it frees itself from the bonds of photographic reproduction and becomes a pure work of man, as animated cartoon or painting" (Arnheim 1964, 213). And from a certain perspective, this is what has in fact come to pass with digital cinema, as Lev Manovich argued two decades ago and as I'll begin to detail in the next chapters (Manovich 1995).

These debates reflect shifts in cultural understandings of and assumptions about images between the twentieth-century cinematic regime and the twenty-first-century animatic apparatus and, in turn, assumptions about how these shape conceptions of life and how they are shaped by them. These assumptions are determined in important ways by the material structure of images, certainly, but they are not fully determined by them. These are rather underdetermined features, to take a term from Thomas Lamarre's wonderful discussion of anime images and the regime of perception they both reflect and produce (Lamarre 2009). That is, the material conditions establish a set of coordinates, but these conditions may open up as many possibilities as they foreclose. (And, as in the case of Fellini, assumptions of indexicality need not be lodged in realist approaches.)

To describe this broad shift in the status of images between the

cinematic and the animatic modes of production in simple terms, in the twentieth century, when spectators saw a photograph or film, they generally assumed it must possess an indexical relation to a real world. This doesn't mean that they might not have questioned whether it was staged or manipulated, but that the fundamental response to photographic images was that they depicted "reality." As I suggested in the Introduction, media ethology is a consideration of how we make sense (meaning) of sense (sensation) as these emerge together—and constitute one another—at the spectator-screen nexus, where the underdetermining material changes in the processes of image production meet the popular conceptions that accompany these changes and the changes in the aesthetic ideologies that surround them. We can see here how the assumption of indexical reality subtends questions around cinematic life: in the twentieth century, the cinematic image displayed and, as in the case of watching *La Dolce Vita* in *Intervista* or watching old movies more generally, *returned* a screen body. Like Ekberg and Mastroianni in *La Dolce Vita*, these are spectral bodies, quasi-ghosts. They oscillate between a form of eternal life and a kind of deathliness. Finitude and death remain important features of "reel life," but they're rendered undecidable, haunted by the afterlife of the body in the image. Life is flickering. Cinematic bodies exist in the space of an ontological crisis: Present or absent? Here or there? Living or dead?

As I described in the Introduction, the new forces of simulation in both art and science are shifting once-dominant cultural paradigms of life in significant ways, moving away from the categorical, ontological distinctions of the cinematic regime to the modes of appearance, metamorphosis, gesture, and affect that characterize the animatic apparatus. Here, we have seen this shift in transformations of biopolitics that occur around the indetermination of its prefix, that is, around the status and structure of the conception of life that has grounded

modern political discourses and practices and in a displacement of cinema's already fraught reality function, and finally, in cinema's ontological crisis and the an-ontology that emerges from it.

Chapter 2

The Animatic Apparatus: Desiring Images

In their introduction to *Remaking Life & Death: Toward an Anthropology of the Biosciences*, a volume that seeks to chart and address transformations in biomedical definitions and practices around the now-unstable boundaries of life and death, Sarah Franklin and Margaret Lock remark,

> We are witnessing a transformation of biology from the scientific study of being into a technology of doing, building, and engineering... both life and death have been recalibrated... The ability to create transgenic sheep with human DNA, to cross a fish with a strawberry, or to patent genetic markers using fluorescent proteins from deep-sea creatures transforms biology from the study of natural history into a set of interventions or techniques (Franklin and Lock 2003, 14).[1]

We can see in Franklin and Lock's description of the new biosciences a shift from representation to production. While we saw forms of engineering also as central to Marey's images and prescriptions of the nineteenth century, this engineering took place on a different stratum and was based on representations of its fundamental category: the animal body, and even more typically, the human animal body. The current practices that Franklin and Lock describe don't begin with a massy anatomical organism, but with biological bits, material or informatic, and these may be exchanged and recombined. 2009 saw the development of the Crispr-Cas9 gene editing technique, now already much in use. Andrew Pollack of the *The New York Times* called it "one of the most monumental discoveries in biology:

a relatively easy way to alter any organism's DNA, just as a computer user can edit a word in a document" (Pollack, 2015). Segments of DNA can be cut-and-pasted. Contrary to pursuing a classificatory logic, these practices eschew category in favor of novelty and the production of forms of life. It doesn't so much matter what life is, but rather what you can do with it.

In his 2003 essay "The Work of Art in the Age of Biocybernetic Reproduction," WJT Mitchell revised Walter Benjamin's famous theses on the work of art in the age of mechanical reproduction.[2] Now, he argues, the double helix meets the Turing machine. Genomic biology and computational media merge. Biological entities and information are united in their sources in code, and we can produce animals through genetic manipulation and living organisms in computational space.

Mitchell's elaboration of the nature of the age of biocybernetic reproduction shows both the diversity and the coherence of its manifestations. He writes:

Biocybernetic reproduction is... the combination of computer technology and biological science that make cloning and genetic engineering possible... [I]t refers to the new technical media and structures of political economy that are transforming the conditions of all living organisms... Biocybernetics ranges from the most grandiose plans to engineer a brave new world of perfect cyborgs to the familiar scene of the American health club, where obese, middle-aged consumers are sweating and straining while wired up to any number of digital monitors that keep track of their... vital statistics (Mitchell 2003, 483).

Mitchell draws a powerful connection here between, on one side, science fiction's extreme visions of genetic engineering and their real-world counterparts, now hotly debated by "bioethicists," and, on the other, the everyday life of the biocybernetic subject,

whose micromanaged and micro-modulated existence wires him or her, at the deepest visceral and affective level, into the power circuits of the political economy of bodily communication and control.[3]

Mitchell points us in the right direction here. Even if cloning and some of the radical forms of body-machine fusion that many science fiction films depict still feel distant from everyday existence, the new horizon opened by the possibility of a radical transformation of biological life changes the orientation of human being; it disorients the human in a fundamental way.[4] The gene editing technology described above has recently been approved for use in human embryos, even where it would affect heritable traits. These techniques of biocybernetic reproduction occur alongside the quotidian manifestations of biocybernetics — and biopolitics — that Mitchell pictures in the sweaty, middle-aged runner on the treadmill, checking on his speed, heart rate, and caloric expenditure. The advent of elaborate fitness trackers and apps that chart the phases of fetal development in relation to changes in the maternal bodies of pregnant women have of course only intensified the presence of biopolitical auto-monitoring in our daily lives. Meanwhile, the contemporary visibility of narratives about trans bodies regularly showcases potentials for bodily transformation that, despite a long history, are often pictured as both novel and sensational.

The "lives and loves of images" — the subtitle title and focus of the book in which Mitchell's essay would appear just two years later — now turn on the essential shift in the cultural imaginary he has described: "This is the age of biocybernetic reproduction, when (as we suppose) images really do come alive and want things," Mitchell writes (482). We can see Mitchell's suggestion as a reversal of the conventional direction of representation: instead of producing an image of an existing creature, we can produce a living being from an image. At the same time, images possess their own forms of vitality. To extend the implications

further, Mitchell's formulation suggests the increasing generative and structural powers of images as they operate across cultural domains.

On Affect

But there's one crucial feature of this transformation that Mitchell surprisingly overlooks: that is, the importance of affective forces in the changing relations and qualities of images and bodies. One of the characteristics of the animatic apparatus, or, "the age of biocybernetic reproduction," to use his terms, is the way in which his picture of the gym rat—wired into the machine, his movements timed to its movements—is not too distant from one we might want to draw of a spectator, whether at a theater, on a couch, or in front of a computer. Even if she is not *literally* wired into the screen, its images and sounds trigger corporeal responses as well as emotional and intellectual ones. A downward plummet in an action movie makes our stomachs drop. The view from a mountaintop gives us a physical sense of exhilaration. It's only because we are connected to the audiovisions in such an intimate way that a jump scare in a horror movie makes us jump, or the lead-up to it makes the hairs on our necks stand up. One of the central features of our age is the increasingly technically structured and micro-modulated nature of our daily existences. While this feature obtains, of course, in those parts of life that we would describe as most directly connected to our physiological and biological existence (medicine, exercise, sexuality, nutrition), it also applies to the ways in which we consume media.

In fact, as Jonathan Beller has argued so brilliantly, the most important transformations of the twentieth century take place at "the attention-screen nexus," where "the cinematic organization of attention yields a situation in which attention, in all forms imaginable and yet to be imagined (from assembly line work, to cinematic spectatorship, to internet-working and beyond), is that necessary cybernetic relation to the socius—the totality of the

social—for the production of value for late capitalism" (Beller 2006, 4). The "attentional biopower" that crosses the attention-screen or spectator-image nexus may be more powerful even than the more conventional biopolitical formations (of medicine and reproduction, for example), because consciousness and the unconscious—all forms of psycho-physical subjectivation—pass through the structuring functions of this nexus and are then fed back into capital accumulation and regulation.[5]

To take a very literal example, the new field of neurocinematics makes it possible for neurologists to study how cinematic images affect the brain, while producers, directors or marketing teams can, and sometimes do, use it to measure and calibrate their effects.[6]

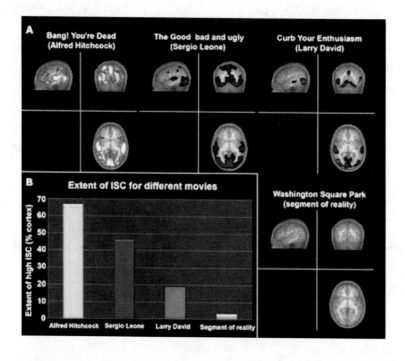

The image above charts ISC, intersubjective correlation, that is, how many of the test subjects' cranial activity matched at particular moments of a film. To obtain these results, test

subjects viewed film sequences from within an fMRI machine. As they watched, the fMRI measured their brain activity in real time. The researchers found that the more structured the film, the more closely the subjects' brain activity correlated throughout. In this example, Hitchcock beats Leone, while Larry David and a sequence of "reality" trail far behind. While it's not surprising that there would be higher ISC for a Michael Bay action film than for Andy Warhol's *Sleep*, the notion of using fMRIs to create and test action or horror or pornographic sequences points to the possibility of more extreme scenarios of the capitalization of affective response.[7]

While affect has become an important subject for media studies over the last few decades, and even a kind of subfield in various disciplines, its meanings are so multiple I want to comment on how I'm using it here. I use the term "affect" — following Deleuze and Guattari, as well as theorists who have extended their work, including Brian Massumi and Steven Shaviro — to emphasize the subtle strata of psycho-physical response that subtends both representational thought and the formation of emotion. Shaviro's definitional terms are helpful here: He describes affect as "non-conscious, asubjective or presubjective, asignifying, unqualified and intensive; while emotion is derivative, conscious, qualified and meaningful" (Shaviro 2010, 3). Emotion is produced as a subject gathers and figures a set of perceptions and affects, naming them "joy," "pleasure," "fear," "irritation," etc. and thus inscribing them in subjectivity's unfolding narrative. Affect is always just beyond the control threshold of the subject — the subject is "traversed by," but doesn't "possess" affect.

One of today's most astute thinkers of gender and sexuality, Paul B. Preciado, highlights the centrality of media's uses and productions of affective forces in the production of gender and desire. He refers to our age as the "pharmacopornographic era," pointing to pharmacology and the proliferation of pornography as its central features. He explains that the culture industry's

greatest desire is:

> to affect the techno-organic centers of the production of subjectivity (centers for the production of pleasure, affect, a feeling of omnipotence and comfort) with the same efficiency as pornography. The cultural industry is *porn envy*. Pornography isn't simply a cultural industry like others; it's the paradigm for all cultural industries (Preciado 2013, 271).

The culture industry's "porn envy" stresses the spectator-screen nexus as a source of our contemporary form of politico-libidinal economy and its production of bodies. While the neurocinematic diagram pictured above, with its disembodied brains, hardly captures the thick embodiment and orgasmic energies that Preciado describes in his major work, *Testo Junkie*, we can see the resonance between his notion of the culture industry's quest "to affect the techno-organic centers of the production of subjectivity" and the lit-up images of brain activity pictured.

Neurocinematics and neuromarketing may again serve as useful examples. The eye tracking, biometric monitoring, and fMRIs they use are designed to work around the unreliability of narrative accounts. This aspect of marketing research seeks to bypass the conscious response of the subject, that is, what they may say on a response form or in a focus group, to capture direct physiological responses. Let's take a look at the Time Warner Medialab's description of its work on its website:

> Biometric monitoring is the practice of monitoring human biological responses as a means of understanding unconscious emotional responses to media, marketing, and advertising content. The biometric measures tracked are the biological changes in heart rate, breathing patterns, skin sweat levels (skin conductance), and motion. In the Time Warner Medialab, the combination of non-invasive unobtrusive

biometric monitoring with traditional research methods allows researchers to know when a subject is actively engaged at both the conscious and emotional (unconscious) levels.

To cite another example, the aptly named Affectiva brings together "affective computing," in this case emotion recognition technologies, and big data. A spin-off of the MIT Media Lab, its Affdex technology uses computer vision and "deep learning" methodologies to produce face and emotion reading algorithms. Using an optical sensor that can work through a basic webcam, their algorithm uses multiple data points to map facial expressions and analyze them in relation to an enormous database. According to their website, they've analyzed 4,824,543 faces and 450B data points thus far. The multinational marketing research giant, Millward Brown, has made Affdex part of its standard client package. CBS uses it to test its new shows. Apparently, as Raffi Khatchadourian notes, "they know how we feel" (Khatchadourian 2015).

But it's also almost impossible not to note the kind of feedback loop all of this tracking and analyzing is producing. Even the most sophisticated algorithm, one that can learn and retool itself, "AI come to life" as Affectiva puts it, operates through specific criteria. It only tracks what it sees, and what it sees is what it can measure. As Hito Steyerl has recently argued, big data may be as subject to apophenia (that is, seeing patterns in random data) as a child seeing a face staring from the clouds (Steyerl 2016). Any agent that participates in the algorithm's programming or data analysis influences the patterns it seeks—and finds. Writing in the very early years of neurocinematics, Shaviro suggests that even if neurocinema is a kind of techno-fantasy that will never be fulfilled, "recent scientific studies already suggest that over the past 75 years, the relative short lengths of Hollywood films have approached ever more closely to the physiological optimum for mental attention" (Shaviro 2010, 121). There's a coalescence

between the development of a scientific standard for mental attention and the development of moving image aesthetics, but the feedback between the two opens new questions about what it means to talk about attention or affect, and how they're shaped historically and technically.

Animatic Analytics

Whether we're talking about "the age of biocybernetic reproduction" as Mitchell does, or about the "digital age," as so many other media theorists do, the reference is specifically to a techno-scientific infrastructure and epistemology—which is then used to explain a cultural scenario. In light of my concerns here, I want to take a somewhat different approach and move away from the languages of biology, computation, and the digital that are so central to our epoch's material-discursive structure. If what is at stake is understanding the new modes of life emerging from contemporary forms of simulation—from biotechnologies, to cinematic animation, to new forms of biopolitics or post-biopolitics—the key can't be the digital or the computational or the biocybernetic. These are merely its features, its technical-material supports. It would be tautological—rather than diagnostic—to ascribe explanatory force to these topoi.[8]

While Beller's formulations regarding the attention-screen nexus are correct when it comes to the macro-economies of capital's spectacle and thus point us toward this nexus as an urgent site of investigation, we need to focus more closely on what happens there. And in order to do so, we need to break open the concept of attention. There's a question of scale in play here. While "attention" names the becoming capital of both image and subject (or "biomass"), it is too monolithic a category when it comes to thinking the work of art. There is an interplay between attention, perception, and affect where each mode feeds back into the others and none emerge precisely the same.[9] If attention replaces labor as "the common social substance" that drives the

machine of capital (or at the very least becomes a signal form of it), it becomes essential to penetrate the mechanisms and vital processes that constitute it.

Animation provides a manner of thinking and analyzing the imaginary that subtends the new simulative forces and forms emerging from this cultural and technical *dispositif*. The characteristic that distinguishes animation as an analytic from, for example, the digital is that animation is a super-medium that (along with all aesthetic media) thinks. I call it a "super-medium" because its diverse variants—imagine stop-motion object animation and classical hand-drawn cel animation (and then add all of the new technical possibilities)—create their own media within it. As we will see, its terrain is mapped not in terms of a luminous, spectral life haunted by temporality, decay, and death, but rather in exchanges between the infinite potential for animatic metamorphoses and the limiting features that in each sub-medium and in each particular case shape and define it, that is, between animation's wondrously various engines of transformation and their respective repetition compulsions and drag coefficients.

While each sub-medium configures the real and the unreal, the animate and the inanimate, in its own particular way, there are a number of things that can be said of animation more generally. In animation, no body fulfills the function of the human body for cinema, where (though this of course obtains only in cinematic and not in animatic forms of cinema) it grounds and unifies its operations. Analyses of biopower, along with particular conceptions of ontology—or hauntology—were contemporaneous with the cinematic regime and spoke to its particular conditions. The very concept of an animatic regime raises the question of what happens to both biopolitics and ontology when the notion of bio—and the mediological image of the (usually) human body to which it was so closely linked— is displaced into the virtualization of life that we will see in

animatic forms in which image-body-life are always passing into or out of existence.

Where can we find media—as technics and as aesthetic practices—developing lives of their own? Or, put another way, because artworks do not just represent, but also conceive and produce affective configurations, what new kinds of subjects— or forms of life—are born from these generative matrices? If all life from the cellular to the organismic to the planetary levels is not autonomous, but interdependent, how do conjugations of images and other beings engender emergent forms?

Chapter 3

Phantasmatic Simulacra and Anti-Pinocchios

Having lost a moral existence to enter into an aesthetic one, we have become simulacra.
—Gilles Deleuze, "Plato and the Simulacrum"

The question of how media can produce forms of life is of course not itself new. From Pygmalion and Galatea, Frankenstein, and Pinocchio to *Innocence* and the 2015 film *Ex Machina* (among many other works), artists have imagined the scenario of a statue, puppet, or android coming to life. Forms of life have played another kind of role in art and media history, as well, in discourses and tropes configured around vitality, vividness, and the classical rhetorical concept of *enargeia*. New today is the way in which these narratives and aesthetic permutations dovetail in what I described in Chapter 2 as the affect-driven forces of contemporary media culture.

In this chapter, I will look at "animating" narratives and "animated" aesthetics in relation to a concept that draws these together—that of the simulacrum. I return to this concept, despite its somewhat confounding turns in twentieth-century critical theory, because it links the artificial lives of puppets, dolls, and cyborgs to the problematic of representation and, for my purposes here, to a critique of it. As I will discuss in Chapter 6, it also holds open a space for thinking dimensions of aesthetics that operate outside the logic of representation, or perhaps more accurately, at a kind of tangent to it. This project engages treatments of the topic of the simulacrum in twentieth-century critical theory, but in a crosswise or oblique fashion, as I will describe.

The Simulacrum

The term "simulacrum" is closely associated with Jean Baudrillard, whose *Simulacra and Simulation* (first published in French in 1981) became a touchstone for media and art theory through the 1980s and 1990s. Baudrillard argues that in the contemporary media sphere, the real no longer exists. It has been replaced by simulacra. He maps a series of historical relationships between reality and images that moves from a view that images represent reality, to one in which they misrepresent reality, to one in which images hide the absence of reality, finally arriving at the emergence of simulacra, images that substitute for reality entirely. Baudrillard gives a definition of simulation via Littré: "Someone who feigns an illness can simply go to bed and pretend he is ill. Someone who simulates an illness produces in himself some of the symptoms." If someone feigns a fever, they're acting. If someone simulates a fever, they nonetheless have a fever. Thus, Baudrillard argues, "feigning or dissimulating leaves the reality principle intact: the difference is always clear, it is only masked; whereas simulation threatens the difference between 'true' and 'false,' between 'real' and 'imaginary'" (Baudrillard 1994, 3).

While I find this example useful, there's something vexing about the way it remains within the logic of representation and reality. We can see this quite clearly in its invocation of intention and strategy. That is, in both cases that Littré/Baudrillard present, the causes are the same. It's only the results that differ. We can argue that the fever simulator is just a better actor than the pretender. In *Simulacra and Simulation*, we always have a sense of simulation as intentional and manipulative and the real as something that has been lost. Baudrillard's lament about the contemporary cultural sphere—ambivalent as it is—thus remains very much itself within the logic it argues is upended by the regime of simulacra and simulation. The reality that has been "lost" in the age of simulation shadows his argument.

Gilles Deleuze develops the concept of the simulacrum in two of his most important works, *Difference and Repetition* and *The Logic of Sense*, but subsequently drops it from his conceptual lexicon. The most important text for my own development of the concept of the simulacrum is Deleuze's "Plato and the Simulacrum," published as an appendix to *The Logic of Sense*.[1] According to Deleuze, pursuing what Nietzsche framed as the "overthrow of Platonism," the motivation behind Plato's iconology is a kind of sorting and classification according to an image's degree of relation to the Idea. For Plato, the simulacrum is the worst kind of image, a degraded copy of a copy. For Deleuze, however, the simulacrum operates outside this sphere of relations between ideas, models, and copies. Beyond the purview of an aesthetics devoted to reflecting the world, the simulacrum participates in the other definition of aesthetics—in a kind of experimental science of perception, sensation, and affect.

Deleuze's discussion of the simulacrum in this essay is, like Plato's, an iconology that doesn't engage questions about the changing material coordinates and operations of images. If Deleuze were to have returned to the simulacrum later, in or after "Postscript on the Societies of Control," with its analyses of the computer as contemporary culture's expressive machine— that is, not as a technological determinant of a cultural *dispositif*, but rather as a machine that expresses its operations—he might have taken it in the direction I do here. Baudrillard, on the contrary, clearly laid out the importance of computational mechanisms—"miniaturized units, matrices, memory banks and command models"—in the generation of contemporary forms of simulation (3).

As a background for discussing what happens when the simulacrum encounters the new technological operations of simulation, let's turn to historical traditions of thinking artificial beings as simulacra. As I began to describe in the Introduction, there are two main tendencies in narratives about artificial beings,

a mainstream version that positions human reality as a goal for artificial life and a counter-tradition that views artificial lives as essentially different from—and often preferable to—human lives. A contemporary example of the mainstream tradition is Steven Spielberg's *A.I.* (2001), an updated Pinocchio story.

Pinocchios

In *A.I.*, Professor Hobby and his team at Cybertronics build a robot boy who is programmed with the capacity to love. His love is not indiscriminate, however. An owner must activate the love program by saying a sequence of words. The boy's love is then focused on that person and, once activated, it can never be reversed. One of Cybertronics' employees, Henry Swinton, has a son who has been frozen in suspended animation, waiting for a future cure for a currently fatal disease. His wife, Monica, is obsessed with her lost son, stuck in a kind of hopeful mourning without finality or resolution. Cybertronics offers the David prototype to Monica and Henry. Despite some hesitation, Monica eventually activates David's love. Then, her "real" son is brought back to life, and a series of jealous contests ensue between the two boys. When one of these leads to their real son's near drowning, Henry insists that David be returned to Cybertronics for destruction. Appalled by this prospect, Monica pretends to take him there, but then leaves him in a forest with Teddy, his "living" teddy bear, where he lives as an unregistered Mecha hunted by the authorities. The rest of the complicated narrative follows David in his quest to find the Blue Fairy, a character from Pinocchio, in the belief that the Blue Fairy can make him real and that Monica will then love him and take him back.

While David never does become real, the story hinges on what is unique about him as a Mecha: While most Mechas look like humans externally, but are internally different, David is defined throughout the film by his functional, operational similarity

to humans. His ability to love, although it is "imprinted" in a highly programmatic way, drives him—or allows him—to formulate extra-rational, creative desires and plans. According to Professor Hobby, it is precisely these two characteristics— love and an irrational creativity that in fact manifests in material change—that most define what it means to be human.

One relevant production fact about the film is that it was originally Stanley Kubrick's project. He started working on the idea for it in the 1970s. One of the reasons it languished in "development hell" and then pre-production for so long before he finally handed the project over to Spielberg is because Kubrick was determined to have David be rendered by robotics and special effects and felt that the technical capabilities weren't fully enough developed to fulfill his vision. In the version that Spielberg made, David is played—and quite well—by a very real boy actor, Haley Joel Osment. Despite the success of the performance, the effect was no doubt very different from the one Kubrick originally desired.

A.I.'s story is familiar. It evokes not only Pinocchio, but Frankenstein and all of the narratives in which an artificial being is produced by a creator, and the subsequent drama emerges from its relation to the human. While in *A.I.* this drama plays out in a world where the new capabilities of simulation emerge from the technological capacities of "biocybernetics," as Mitchell argues, the animating dream is to produce an artificial human who can transcend its technicity and artificiality.

Anti-Pinocchios

But there's another tradition, and, as I've suggested, it is much more useful in thinking the forms of life of the animatic apparatus. My main contemporary example will be Mamoru Oshii's *Innocence*. But before we get there, I want to take a look at a kind of urtext of this countertradition, Kleist's "On the Marionette Theater," because when we get to *Innocence*, we'll see

how Oshii deploys a kind of a-human, affective poetics that we'll find thematized—and enacted—in Kleist's text.

In 1811, Heinrich von Kleist, German Romantic author and playwright, produced a strange tale—a hybrid of essay, fiction, and dialogue—that seems now to have been written just for us. "On the Marionette Theater" is an untimely parable for the animatic apparatus and one that can help us to conceive the lives of medial creatures as related to conditions of technicity before and beyond the logics of biology and computation. The narrative launches from the insistent assertion of one of its two interlocutors that even the most talented of human dancers can never achieve the grace of a marionette: The puppet is not a poor copy of a human, but a dazzlingly different kind of being. It is not a purely autonomous entity, however, and not at all an optimized cyborg that would replace human frailties with superhuman perfections. The marionette also needs its others. It exists in a symbiotic—and, in fact, prosthetic—relation to its operator and has the capacity to lead him, in the company of all manner of species, back to a paradise once forfeited to the exigencies of human consciousness. While Kleist calls this new paradise "innocence," it's not quite the same as the original. Paradise is regained, but differently. And what is to be reassumed is an innocence on the far side of knowledge, an affective extra-human becoming after the ordeal of human self-consciousness.

"On the Marionette Theater" is an extremely difficult work to summarize, and for a reason that is central to its powers: its engine is a strange kind of affective poetics. As I noted above, it is part story, part essay, related as a dialogue between two acquaintances. Their topic is a marionette theater they've both seen in the village square, and their discussion of this scenario—along with what Paul de Man calls the work's additional "scenes of instruction" (de Man 1984)—is embedded within the interlocutors' own theater of affects, in the performance of each speaker, who may lift his head, clear his throat, or take a pinch

of snuff, and in their credulous or incredulous responses to one another. For Deleuze and Guattari, "Kleist" is the proper name of a very particular kind of counter-hegemonic poetics, one that travels via series of affects that refuse to coalesce into a picture, a subject, or a state. "No form develops, no subject forms: affects are displaced, becomings catapult forward and combine into blocks... All of Kleist's work is traversed by a war machine against the State, a musical machine invoked against painting or the 'picture'" (Deleuze and Guattari 1987, 268). It's an animatic, an-ontological poetics: Melodies and rhythms undermine the figure, the outline, the entity.

The doll theme, as I call it—at least as it runs from Kleist to Oshii (and we see this elsewhere, as well)—draws with it this insistence on a particular transformative and de-subjectivizing deployment of technics and artifice that plays affect over consciousness, the inhuman over the human. It's the target zone of animatic aesthetics. When we get to *Innocence*, we'll see how Oshii deploys a kind of a-human, affective poetics that we'll find thematized—and enacted—in Kleist's text.

In "On the Marionette Theater," Herr C— a principal dancer in the town's company—insists that a marionette may possess more grace than would ever be possible for a human dancer. Human dancers, he argues, are hindered by their very consciousness, which results in unfortunate affectations. One dancer's "center of intention" gets caught in the vertebrae of her lower back, and "young F— when, as Paris, he stands among the goddesses and presents the apple to Venus, his soul is (oh painful to behold!) in his elbow" (Kleist 1989, 417). This affectation presents a real conundrum for the human, who is barred from paradise—which Kleist also refers to as "grace" and as "innocence"—by its self-consciousness. The first scenario, related by Herr C—, centers on the marionette. The second, imparted by the narrator, tells the story of a youth who loses all of his charm when he becomes aware of it. The third, again narrated by Herr C—, revolves

around a fencing bear who, because of his very lack of human consciousness and self-consciousness, is immune to any feint and can parry any blow. These two latter narratives work to frame the one concerning the marionette, for it is this one that indicates a potential way back to "innocence."

The marionette will function as a prosthetic, allowing the human dancer to achieve an inhuman grace. Herr C— "smiled and said he ventured to maintain that if a mechanic would build a marionette for him according to the requirements he gave him, he would perform a dance with it that neither he nor any capable dancer of his time... was in a position to equal." He asks the narrator if he has "heard of those mechanical legs that English artists fabricate for unfortunates who have lost their limbs." When the narrator answers in the negative, Herr C— replies, "If I tell you that those unfortunates dance with them, I'm almost afraid you won't believe me... Certainly the range of their movements is limited; but those at their disposal are accomplished with an ease, lightness and grace that astonish every sensible mind." The requirements for producing the marionette are "already found in them as well—symmetry, mobility, lightness (but all to a higher degree), and especially a more natural arrangement of the centers of gravity" (Kleist 1989, 416).

One very interesting aspect of how the puppet-prosthetic functions in "Marionette Theater" hinges on its relation to its operator (a subject that receives some sustained attention in Kleist's very brief work). While at one point Herr C— indicates that the perfect marionette (the one manufactured by the prosthetic maker) will be able to work all on its own, he at once maintains that there is a necessary (if thus paradoxical) relation between puppet and operator.

As Richard Shiff notes, Kleist complicates "any thought of differentiating or prioritizing the roles of marionette and animator-master. He also complicates distinctions between spontaneity, willful control, and automatism" (Shiff 2002,

339). If Kleist's fantasy were a perfectly autonomous puppet, it would be something entirely different than it is here: it is via the circuit that its machinic, inhuman life enters into with our own lives that it can transform perception via its inhuman affect. This perceptual and ontological transformation is the central aspiration of Kleist's marionette—and of Oshii's doll film. The simulacral object or image includes the perspective of the spectator—"the spectator is made part of the simulacrum"—and transforms it (Deleuze 1983, 49).

While *A.I.*'s David is the product of enormous technological sophistication, his overcoming of artificiality and his attainment of humanity is also framed as a transcendence of technology itself (though Dominic Pettman might argue that what the tale illustrates is the technicity—the techno-cultural programming—of human love). We find a very different scenario in "On the Marionette Theater." A brief foray into Kleist's intellectual biography can help illuminate the unusual, and prescient, conceptions of technics he develops in "Marionette Theater." Much of the literature on Kleist describes his work as a response to what is commonly called his "Kant crisis": When Kleist was a young man, his belief that the purpose of life is to move toward an absolute truth collided with his reading of Kantian philosophy: The conception that the mind structures apprehension and understanding catapulted him into a kind of two-year-long nervous breakdown.[2] In the letters Kleist wrote in the period of the crisis, he posited a technical structuring of human perception as an analogy for the impurity—that is, the technicity—of human understanding: "If everyone had green eyeglasses instead of eyes," he wrote to his then-fiancée, Wilhelmine von Zenge, "they would be forced to judge that all the objects they could see were green. They would never be able to decide whether their eyes saw things as they really are, or whether they added something of their own. This is the way it is with our understanding" (Kleist 2004, 421). In

"On the Marionette Theater," Kleist would convert his post-Kantian despair, first, into a critique of human consciousness, anthropocentric humanism, and the human itself, and second, into a kind of utopian overcoming of this limited consciousness via the media-technical object—in this case, of course, via the marionette. The marionette—unlike the green lenses, which were, in effect, forced on Kleist by his sobering realizations—was a purposive prosthetic, one explicitly designed to lead the human beyond this limited vision and into a new "innocence."

Kleist's innocence is not reducible to a Romantic topos of natural, childlike grace. On the contrary, Lisabeth During explains that, for Kleist, "after the ordeal of skepticism, for which philosophy is in part responsible, innocence can never be childlike again: it returns in new and inhuman forms, as machine, as monster, as beast, as god" (During 2009). And this return is precisely what transpires in "On the Marionette Theater." Its darkness lies in the infelicitous affectations of its humans and in the wounds of the soldiers from whose misfortune the prosthetics maker hones his skill.

The marionette, however, provides a means of transportation to another state:

"Now then my excellent friend," said Herr C—, "you are in possession of everything necessary to understand me. We see that in the organic world, to the extent that reflection grows dimmer and weaker, the grace therein becomes more brilliant and powerful. Yet, just as the intersection of two lines on one side of a point suddenly appears again on the other side after passing though the infinite; or the image in a concave mirror, after receding into the infinite, suddenly resurfaces close before us—grace likewise reappears where knowledge has passed through the infinite, so that it appears purest simultaneously in the human body that has either none at all or infinite consciousness—that is, in the puppet or in the

god."

"Consequently," I said a little distraught, "we would have to eat again from the tree of knowledge to fall back into the state of innocence?"

"Of course," he answered, "that is the last chapter of the history of the world" (Kleist 1989, 420).

This strange and wonderful passage gains its force through the power of its very irreconcilability, its exhaustion of the mechanics of reason. Given that Kleist is at least nominally a Romantic, it is not surprising to see his reference to an organic world in which "to the extent that reflection grows dimmer and weaker, the grace therein becomes more brilliant and powerful." But we see almost immediately how insistently Kleist's formulation runs against the grain of Romantic *Naturphilosophie*'s exalted organic archetypes: the grace that appears through the absence of consciousness in the puppet or through the infinite consciousness of the god is processed by the technical interfaces of the geometrical diagram and the concave mirror. It is after technics. And it is not the organic that has the final word here, but rather those figures that exist at the edges—or just beyond—the reaches of its possibility. Kleist's puppet, as the human body without consciousness, has been produced through a precise construction of and as a technical prosthetic, and we might well conclude that Kleist's god has been engendered in like fashion.

If we look closely at Kleist's series of examples, from the green glasses, to the mechanical legs for amputees, to the diagram, the mirror, the marionette, and finally grace itself, we see a technical ordering of the natural world and of the process of perception at the heart of his vision of innocence. We are always already artificial beings. Technicity is originary, to use Derrida's famous formulation. What we think of as "the human"—along with all forms of life—emerges in relation to it. Kleist, in his image of the green glasses that color our understanding, already goes

far beyond Kant by positing an *a priori* technical synthesis, an *a priori* prosthetics of perception.

I would argue, even, that the way Kleist positions technics as constitutive of new forms of human life provokes him to aspire to something like animation before the fact. Oshii, in turn, uses the material and medial means at his disposal to answer and extend Kleist's demand. For both, the doll or puppet—as simulacrum—embodies an aesthetic experiment in moving beyond the limitations of human consciousness and knowledge. As philosopher and critic James Phillips remarks, "for the site of freedom to be opened, for Kleist, it must be open to animals and marionettes" (Phillips 2007, 97). The marionette and its successor, the animated film, become the back doors through which the state of innocence might be assumed a second time— but differently. This hinges on the ability of these an-ontological machines to trigger contacts and exchanges between the human and its others.

In 2004, Mamoru Oshii remade "On the Marionette Theater" as an anime feature, a stunningly rendered mixture of 2D and 3D animation that quotes, along with Kleist, Milton and Freud, Descartes and La Mettrie, Villiers de L'Isle Adam and Raymond Roussel, and that even includes Donna Haraway as a character. In a complex dramaturgy and restaging of the Romantic tale, *Ghost in the Shell 2: Innocence* enacts a philosophical treatise on the animatic apparatus—on the ways of the animate and the inanimate; on the modes of humans, machines, and animals; on the historical discourses on the mechanical and the vital. While the plot is interesting for the manner in which it reconfigures some of the now conventional tropes of the science fiction narrative, what is special about this work is the interplay between its thematizations of the question of the "life" of dolls, automata, and cyborgs, and the manner in which it fashions itself as a kind of automaton. In fact, it asks the spectator from the very opening sequence to regard the film itself as a doll.

41

Whereas *A.I.* projects the bourgeois environment of late consumer capitalism into the future via an updated version of the same old (quite self-conscious) Oedipalized family drama, *Innocence*'s tale constantly questions the centrality of the human, both in its plot and via its visual imagination of its characters—androids, gynoids, cyborgs, and variously modified humans. The film is in fact a very explicit critique of anthropocentric humanism, and the doll (though joined by the god and the basset hound) is its central figure.

The unusual context of *Innocence* deserves special comment. Its combination of philosophical themes, stunning visuals, and action narrative—as well as the particular hybrid of popular and highbrow forms—are unique to Oshii's work. While Japanese manga and popular animation have always been broader in target audience and generic range than their European and American counterparts,[3] *Innocence*'s intertextuality is likely equaled only by some films by Godard, to whose citational method Oshii explicitly declares his fidelity, and Oshii's references, also like Godard's, are predominantly to a European philosophical, literary, and cinematic canon. The film premiered at Cannes in 2004.

Oshii draws on and reconfigures the philosophical history of the automaton and the doll, at once providing a new genealogy for contemporary simulative modes of audiovisual culture, and using these figures as operative models for a series of perceptual experiments.[4] Like "On the Marionette Theater," the film's form allegorizes its content (and vice versa); that is, it enacts the theory it purveys. That *Innocence* is a treatise in the form of an animated film, rather than a philosophical text, makes it enormously challenging to discuss, but also an amazingly fecund source for reflection on the shifting dimensions of spectacular culture. It is the much-awaited sequel to Oshii's 1995 anime classic *Ghost in the Shell*. *Ghost* 1 is, generically speaking, like *Innocence*, an action film, but its real center is the musings of its heroine on

the problem of her identity. Major Motoko Kusanagi is a full cyborg—her body is in fact owned by the government that employs her as an elite cyber-crimes cop—and the only thing that ties her to her humanity is the trace of a "ghost" (a kind of soul or identity pattern) that remains amid the proprietary hardware and software of her being. Rather than finding a way to confirm or solidify the major's ontological autonomy and integrity, the film takes off in another direction entirely: at its end, she merges with the "Puppetmaster," a new form of autonomous AI born from the net. She thus leaves her cyborg shell behind to assume a new form of virtual existence. She can, however, incarnate certain aspects of her new vast "subjectivity" in cyborg bodies, and at the end of the film, she converses with her partner, Batou, in the assumed body of a doll-like young girl.

Innocence picks up where *Ghost* 1 left off, but its central character is Batou, the major's former partner and now head of the Section 9 cybercrimes unit. He is a large, muscular lens-eyed cop who's almost as much of a cyborg as the major was. It is implied that Batou was in love with the major, but this is a very particular chaste species of love. It is structured by a distance that he seems uninterested in overcoming—and he is presented as a melancholy loner whose closest relationship is with his basset hound, Gabriel. (Gabriel is actually quite an important character in the film's philosophical drama; he is the avatar of humanism in this in- or post-human scenario.) Batou and his almost fully human partner, Togusa, are sent to investigate the murders committed by the gynoids. To viewers of *Ghost* 1, the dolls of *Innocence* reference Kusanagi and her ontological conundrums, despite the contrast between the major's authority—she was clearly the leader of the Section 9 team—and the "gynoids" status as "pets." Where *Ghost* 1 revolved around Kusanagi's reflections, *Innocence* is oriented by Batou's alienated melancholy and his special sympathies with dolls and animals.

Innocence always insists on the irreducible difference of its

43

dolls. Far from depicting realness and humanness as the goal for the artificial subject, *Innocence* presents doll consciousness and subjectivity (or doll unconsciousness and objectivity) as valued states. It is the desirability of human consciousness—and of humanity itself—that is in question.

In the conclusion to the film's plot, its protagonist, Section 9 detective Batou, who is himself almost a complete cyborg, discovers that the company that manufactures the berserk sex dolls is kidnapping young girls and "dubbing their ghosts" (that is, copying their identities or souls or unique patterns—"ghost" is a complicated concept) into the dolls. An inspector discovers this illegal act, and reprograms the dolls to cause trouble so that the police will investigate and the real girls will ultimately be rescued. When Batou finds the kidnapped girls, however, his sympathy lies not with them, but with the dolls. When the girl they find alive explains what happened, Batou says, "Didn't he consider the victims? Not the humans. What about the dolls endowed with souls? If the dolls could speak, no doubt they'd scream, 'I didn't want to become human.'" While *A.I.* asks us to have sympathy for David, it does this on the basis of David's ultimate similarity to humans. It is because he possesses these human mechanisms of love and dream that he is deserving of our identification and sympathy. Batou, on the other hand, is concerned to preserve the dolls' difference.

The high-tech sex dolls of *Innocence* are referred to as "gynoids," and the specific model that is the focus of the film's plot is the "Hadaly," named after the artificial woman of Villiers de l'Isle Adam's 1886 novel, *L'Eve future*. The Hadaly gynoids, like their literary precursor, who is built by a mad Edison-like inventor to the specifications of his decadent aristocratic client, are also living pictures, built in an idealized image.

As we can see, Oshii's creatures are quite distinct from David: They are anti-Pinocchios. They may want many things, but they don't want to become "real," and they don't want to become

human. The difference between *A.I.*'s David and *Innocence*'s dolls makes their stories philosophical opposites. We can think these differences in relation to divergent histories of artificial life, one in the line of Pinocchio (though readers of Collodi's tale know this is not nearly as straightforward as Disney would have us believe), and the other in the line of Kleist's marionette. They likewise advance contrasting pictures of the simulacrum, both within their narratives and in their modes of composition, their perceptual coordinates, and the affects they generate.

The difference between David and the gynoids is the difference between what Deleuze characterizes as the model or copy, on one hand, and the phantasmatic simulacrum, on the other. Copies "are secondhand possessors... authorized by resemblance," where the resemblance is always "interior and spiritual." The simulacrum, however, only appears to resemble, only "produces an effect of resemblance." But this effect is "wholly external, and produced by entirely different means from those that are at work in the model" (Deleuze 1983, 49). As the movie pictures David, as we've seen, he has a well-grounded claim to model the human. He participates in its Idea, via his ability to love and his drive to create, and this is the center of the narrative. The gynoids do possess an external effect of resemblance to the human (I'll go into more detail about their physical appearance below), but Oshii consistently insists on their dissimilarity.

There are thus two forms of artificial life here, one that echoes the morality play of Pinocchio's quest to become real and the other that emerges from the affective poetics of Kleist's graceful marionette. While the narrative morality of *A.I.* hinges on David's status as model, copy, and likeness, the aesthetic method of *Innocence* hinges on the otherness of the simulacrum. The gynoids' points of reference to the human form only mask essential differences. "The simulacrum is constructed around a disparity, a difference; it interiorizes a dissimilitude," Deleuze explains. "If the simulacrum still has a model, it is another

45

one, a model of the Other from which follows an interiorized dissimilarity" (49). The dolls are modeled on their difference from humans. This difference itself is their source. These dolls are thus emblems and performers of the very possibilities of differentiation and perceptual transformation, in particular as these differences and new perceptions come from outside of the human and draw the human outside of itself.

The simulacrum is thus itself a kind of apparatus, one that functions according to different protocols, we might say, than other kinds of images. Today, the simulacrum apparatus, which we saw Kleist develop out of his formulation of originary technicity, encounters and extends the new affordances of biotech. This is precisely what animation helps us to think. Oshii considers it via the dolls in *Innocence*.

Chapter 4

The Doll Theme: Object Lessons in An-Ontology

In an interview for the *Village Voice*, J. Hoberman suggests that *Innocence* "might be an allegory about animation," and a cryptic Oshii replies only that filmmaking has much in common with doll making (Hoberman 2004). Oshii begins to establish his film's doll character at the very beginning—of the film and of time itself. In *Innocence*'s visually stunning credit sequence, the Hadaly-model gynoid is equated with the production of the film. Her animatic "birth" is intercut with the names and titles of the film's animators, sound specialists, producers, and finally, with the name of its director.

This echoes the credit sequence of its predecessor, *Ghost* 1's "birth of a cyborg"—but the tropology is quite different. *Ghost* 1's heroine, Kusanagi, is born from the conjugation of a watery biological domain and computer code (the "digital rain" later popularized by the Wachowskis' appropriation of this graphic in *The Matrix* (1999)). This is fitting for a cyborg who will come to merge into a purely virtual dimension (although she is still free to "enter" multiple bodies, as she will in *Innocence*). Kusanagi's matrix is information.

In the second film, the motifs are very different and clearly refer to the images of "On the Marionette Theater."

The opening image is of a mutating sphere against a dark background of cosmic space. The sphere's metamorphoses at once suggest a planet's evolution and the biological domain of embryonic splittings and cell mutations. The cell/planet then takes on a mechanical aspect, only to grow what look like biological tendrils or neuronal webs. Kenji Kawai's haunting Japanese choral soundtrack plays a traditional wedding song.

The birth of the marionette-god then begins in earnest, as a fiber optic spinal cord unfurls across vast space and the soundtrack bubbles. We then see the hand of a jointed puppet, likewise positioned within this cosmic dimension. It gestures to us to enter the image and then turns its palm to reveal that it is empty, its interior a series of filaments. The cosmic marionette next begins to transform: a doll's body slowly assembles around its fiber optic spine. We see two pairs of doll legs attached at a ball-joint middle; they split to form two full doll bodies. The dolls kiss and then drift apart. Only one remains. She spirals feet first

through the watery, dark space and emerges through a swirling and bubbling yellow vortex as a cyborg-type doll with gears in her back, curled into a fetal position, trailing filaments in her wake. The open compartments close, sealing her body. We then see her body unfurl, her doll hair swinging, as we come in to a close-up on her face and finally on her blue doll eye, its iris ringed with writing, like a camera lens. The doll is here equated with the camera, the process of animation, the film itself: She is, as I suggested above, its exemplar and its emblem.

To return to Hoberman's suggestion, we can see Oshii using the figure of the doll to develop something like what Hoberman refers to as "an allegory about animation," but in a much broader sense than Hoberman may have intended. The opening sequence itself introduces one of the film's crucial contributions to the concept of the animatic apparatus, placing it in relation to a history of the quest for artificial life, a history of dolls, puppets, automata, and replicants, rather than in relation to a history of visual representation. The doll's life—which is at once the film's life—is created through an array of materially and technologically heterogeneous elements, organic and inorganic, earthly and cosmic. It doesn't privilege any one of these. Likewise, it incorporates many forms of "artificial" life, referring to a godlike, cosmic marionette, ball-jointed dolls, the gears of the android, the organic-mechanical mixtures of the cyborg.

The kind of theory and genealogy of animation that Oshii develops has many resonances in the theoretical literature on animation, although no one thinker develops these as fully as does Oshii. Animation theorist Alan Cholodenko makes a similar genealogical claim about cinema's historical relation to automata in a very direct way, suggesting that we put animators

in the line that extends from Mary Shelley, Victor Frankenstein and his creation, back to Jaquet-Droz and his automata, and

beyond, to de Vaucanson, and back to the Alexandrian school and Prometheus, Pygmalion, Daedalus, and Hephaestus. The fascination of these filmmakers is in the enduring fascination with animation "as such," with the endowing with/bringing to life and motion, with the artificing of life as such, an artificing that takes us back to classical times, to the artificial man of the automaton and to the "rival" traditions of animism and mechanism (Cholodenko 2011, 495).

While Cholodenko appears here to be speaking very specifically of animation, he will ultimately ask us to displace the conventional disposition that makes cinema the dominant modality and animation a marginal subset. He then extends the proposition to include all of cinema, as well. The cinematic then becomes a subset of a larger, older animatic apparatus—one that dreams, like Pygmalion and Victor Frankenstein, not of representing life, but rather of producing it.[1]

One notable feature of many of the theoretical equations of filmmaking and the artificial lives of dolls and automata that appears in Cholodenko's move from Galatea to Frankenstein's monster, as well as in Oshii's account, is the kind of slippage between cyborg, automaton, living statue, and simple doll that we saw Oshii invoke in his credit sequence. Oshii, as we will see, conjures Donna Haraway, but also has Batou relate the famous story of Descartes' automaton "daughter," Francine, and refers consistently not to cyborgs, but to dolls.[2] This may appear as a purposely ahistorical deployment of this figure, but Daniel Tiffany points us to the manner in which this slippage is in fact an index of a particular modern concern with the status of the image, one that begins with Kleist and wends its way through the works of ETA Hoffmann, the Surrealists, and others. He writes:

Although many questions arise about the displacement of the classical automaton by the doll, it is apparent in the

texts of Kleist and others that this transaction pertains to the demechanization of the automaton, in a manner that, paradoxically, only enhances the autonomy of the device as a simulacrum. That is to say, it pertains to an evolving ontology of pictures in modern culture and to the enduring interdependence of pictures and bodies (Tiffany 2002, 65).

In Kleist et al., questions that were once configured around the automaton are displaced onto the doll. According to Tiffany, the conceptions of the relationships between bodies and pictures that have since antiquity—in the most various forms—structured the debates on material substance that have played out around the emblem of the automaton are increasingly figured in terms of a concern with spectacular culture, and the doll becomes the new emblem.

In my own view, the untimely figure of the doll thus appears as a special marker in an archaeology of discourses on the affective-productive image. Though she uses a different kind of conceptual framework, cultural theorist Giuliana Bruno makes a similar claim in description of cinema as a "sentient automaton": We encounter eighteenth-century sensationalist Étienne Bonnot de Condillac's statue coming to life sense by sense, the precise construction of Villiers' Hadaly of 1886, and *Blade Runner's* sensitive replicants of the 1980s—all bundled together as emblems of cinema's tactile properties (Bruno 2007). Although Bruno invokes these figures in the context of a discussion of cinema's emotional cartographies, we can see how there, too, the automaton/cyborg figures the simulacral operations of the affective image. Where the doll figures the image as simulacrum, it is no longer representational, but productive. It opens a new territory (that I describe in relation to new affective capacities and that Bruno describes as pertaining to emotion), maintaining just enough resemblance so that its potentials—if not the extent of its "dimensions, depths, and distances"—become graspable.[3]

It's significant that a version of the genealogy of animation suggested by Cholodenko and Bruno and extended by Oshii has become something of a commonplace over the last few years, and largely, I would argue, because of the pressures that digital cinema as a form of animation has brought to bear on film history. In Scorsese's fanciful film history in *Hugo* (2011), for example, it is mechanical toys—and particularly a kind of magical android—that provide the launch pad for the development of cinema. This development is portrayed as emerging from the work of Georges Melies, whose fantastic "trick films" used the resources of animation to produce their effects (rather than from the realism and documentary tendencies traditionally ascribed to the Lumière films), and ending in the kind of animatic digital production that *Hugo* is itself. Scorsese's version of this history does not, however, undertake the kind of rigorous theoretical interrogation of these forms that Oshii does.

We've looked at the Kleist text that plays such an important role in Oshii's thinking in *Innocence*. Let's jump to the other end of Oshii's historical trajectory and turn now to his engagement with feminist science studies scholar, Donna Haraway. Haraway's work is not only—like Freud's or Kleist's—quoted in the film: A character, named Coroner Haraway, is in fact modeled (up to her haircut) on the UC Santa Cruz professor. Coroner Haraway has one of the Hadaly bodies in her lab, where she is investigating the source of the malfunction, and Batou and Togusa join her there to discuss the case.

It's clear from the beginning that Haraway's sympathies lie with the Hadalys. She chides Batou for having shot one of them with a highly destructive bullet and laments the contemporary fate of many of these types of being who, once doomed to obsolescence, are forced to wander aimlessly or take their own lives. She, Batou, and Togusa then engage in a philosophical exchange in which Haraway asserts that the difference between humans and machines has always been merely "an article of

faith." The mostly human Togusa, always the voice of more conventional humanist principles, balks at Haraway's assertions, and Batou acts as a kind of speculative mediator, telling a story about Descartes' construction of an automaton that would come to replace his dead daughter in his affections.

In drawing Donna Haraway into the world of the film, Oshii is explicitly engaging an established contemporary academic — and popular — conversation about technoscience, culture, and new forms of individual and political subjectivity.[4] And it is telling that Oshii gives us his own, very particular version of Donna Haraway. Most centrally for our purposes here, where Haraway famously describes "boundary breakdowns" between machine and organism, animal and human, physical and nonphysical, Oshii's Haraway contests the ontological consistency of these categories altogether, positing their emergence in the an-ontological dimension of the animatic.[5]

Yes, if you assume that there is a clear distinction between man and machine.

Haraway suggests that we are all already cyborgs, hybrids of human and machine, biology and cybernetics, and that this is a good thing, at least potentially. She explains that cyborg being is constituted by three central boundary breakdowns — between

machine and organism, human and animal, and physical and nonphysical. While Haraway recognizes the cyborg's genesis as a product of the patriarchal military-industrial complex, she suggests that illegitimate children can be extremely unfaithful to their origins and calls for a cyborg politics that would equip feminism and socialism to face the special challenges of contemporary technoculture and its political-economic coordinates by taking responsibility for the blurring of boundaries and the creation of new forms, rather than by trying to reinstate already defunct pure categories of human, animal, or machinic being.

The way in which Oshii re-stages, critiques, and revises Haraway's massively influential 1985 text, "A Cyborg Manifesto," draws us out of the usual orbit of the cyborg. First, it shifts the historical dimension of the argument about the exchanges between organisms and machines; the questions posed by the fate of the Hadaly are referred back at least as far as the seventeenth century. However, this isn't merely in the service of pointing out that we have always been cyborgs, technical beings who from our very beginning have relied on clothing and buildings, fire and art, to sustain our bodies and cultures (though this is no doubt true, as well as an important part of the film's worldview). More notably and more originally, it displaces the figure of the cyborg with that of the doll. The slippage from automaton to doll occurs in the story of Descartes itself and is then reinforced by the surrounding dialogue about child-rearing and artificial life.

Oshii helps us to rethink the features of Haraway's cyborg in three new ways: by stretching Haraway's confusions of ontological boundaries into the an-ontological dimension of the animatic, by encouraging us to think the contemporary techno-logic of the cyborg through a surprisingly untimely frame of reference: the doll, and by placing this thought of animatic an-ontology in its constitutive relation to the affective dimension of

animatic aesthetics.

I'll reproduce a small portion of the dialogue from the Coroner Haraway episode to demonstrate Oshii's revisions to Haraway's formulations:

Haraway: "Do you have children?"

Togusa: "A daughter."

Haraway: "Children have always been excluded from the customary standards of human behavior, if you define humans as beings who possess a conventional identity and act out of free will. Then what are children who endure in the chaos preceding maturity? They differ profoundly from 'humans,' but they obviously have human form. The dolls that little girls mother are not surrogates for real babies. Little girls aren't so much imitating child rearing, as they are experiencing something deeply akin to child rearing."

Togusa: "What on earth are you talking about?"

Haraway: "Raising children is the simplest way to achieve the ancient dream of artificial life. At least, that's my hypothesis."

Togusa: "Children aren't dolls!"

Batou: "Descartes didn't differentiate man from machine, animate from inanimate. He lost his beloved five-year-old daughter and then named a doll after her, Francine. He doted on her. At least that's what they say."

Togusa: "Can we get back to reality here? I'd like your observations with respect to the Hadaly robot, model #2502, manufactured by Locus Solus."

Here, Batou is channeling Haraway's earlier assertion that the difference between humans and machines is merely an article of faith through a commonly told story of Descartes in which he loses his young daughter and builds a doll—typically, she is rather described as an "automaton"—that fully assumes her place in his affections.

In fact, the various types of beings with which *Innocence* is "peopled"—androids, gynoids, robots, dolls, animals, and humans—are plotted between poles of animate and inanimate, living and dead, and no entity exists at any of the extremes: all are in between. The mise-en-scène of this sequence in particular is itself a kind of catalogue of artificial lives drawn from cinema, literature, and art history—and the marshaling of these figures under the command of Oshii's doll emphasizes his insistence on it as the central figure. The scene "quotes" Ridley Scott's 1982 *Blade Runner*: a vat of floating eyeballs in Haraway's lab echoes the Hannibal Chew scene in which two replicants—genetically engineered superhumans with a four-year life span—look for their maker, but find instead the specialist bioengineer who makes "just eyes."

A gynoid stretched on a stainless-steel table where an apparently specialized medical-industrial machine either probes, assembles, or dismantles her refers to a more contemporary entry, Chris Cunningham's 2000 music video for Bjork's "All is Full of Love," in which Bjork herself appears as a female android. Finally, the Hadaly model gynoid itself, as well as taking its name from the female android of Villiers de l'Isle Adam's 1886 *Future Eve*, resembles the uncanny photographs of dolls produced by German Surrealist Hans Bellmer in the 1930s and 1940s.

The ideas that Oshii's Haraway advances in this scene, suggesting a kind of equivalence between children and dolls, where both are products of a drive to produce artificial life and where children may resemble dolls more than they do adult humans, provide a distilled image of animatic logic, revealing its distance from conventional ontologies and notions of life, and its substitution of an-ontological field for Haraway's breakdown of a mixture of ontological categories. The Descartes who appears here (seeming to think more along the lines of La Mettrie's radical materialism than in terms of his own dualist notion that a god-given soul animates the human machine) loves his progeny—

biological and mechanical—equivalently (La Mettrie 1996). The figure of the child has been precious to humanist narratives, bundling a teleological narrative of biological development and notions of genealogy and family, heredity and descent, into one compact ideological package, neatly tied up with connotations of innocence and imagination.

We can see the resonance—and imbrication—of the image of the child with Franklin and Lock's description of an older model of "life itself" in *Remaking Life & Death*, which refers us "to the unity of all living things through the model of common ancestry and descent" (Franklin and Lock 2003, 14). That the "child" is a conceptual product of the aesthetic and cultural ideologies of the Romantic and Victorian eras is often occluded by this powerful cultural narrative. Seeing the doll as an artifact of childhood reinforces this forgetting. But if we draw out Coroner Haraway's logic, we can flip this scenario, so that rather than the doll being an accessory of the child, the child is an accessory of the doll—an artifact of the modes of determining the nature of life, the relation of animate to inanimate, of play to reality that the tropes of both child and doll figure. What we find, alongside the dismantling of biological, developmental genealogy, is a life become animatic and an-ontological.

Chapter 5

An-Ontology and Animatic Aesthetics

As I noted in the Introduction, the concept of the animatic apparatus describes both animation as a medium, and our contemporary cultural condition—and understanding one will help us to understand the other. Our investigations so far now enable me to further open up the an-ontological dimensions of animation-as-medium.

I want to propose a quite specific definition of the mediality of the animatic here: The animatic is any aspect of image production—from animation as such, to digital special effects, to extreme camera angles—that does not deploy the cinematic reality effect of the index, described above in relation to *Intervista*, as it produces a pro-filmic real. That is, it does not find its raison d'etre in representation. It takes up the simulacral dimensions of the image, or of audiovisuality, to be more precise. This definition of course complicates any strict boundary between cinema and animation: the two modes consistently exchange and transform one another.

The example of an extreme camera angle is an important complicating instance here, because cinematic and animatic modes, as I've argued, are never fully determined by the material technicity of the apparatus. There's an ethological rather than a classificatory engine at work. It's about how images work, how they behave, how they interact with other forces. The "real" of a photographed scene may be deformed from within, and a large portion of animatic production is informed by the register of cinematic realism. This definition of course complicates any strict boundary between cinema and animation: the two modes consistently haunt and transform one another. Cinema and the cinematic age are traversed by the animatic and vice versa, and

this goes for the ways in which the cinematic and the animatic function as cultural modalities, as well.[1]

The animatic mode takes up the simulacral dimensions of the image, or of audiovisuality, to be more precise. It involves a displacement not only of the reality function of cinema, but of the kind of reality principle that continues to operate in the cinematic mode. Where the indexical ideology of cinema posits a necessary relation between the image and, in Cavell's terms, *the* world, animation must always create *a* world.[2] In terms of Deleuze's distinction between the model or copy and the simulacrum, we can say that the simulacrum is already an an-ontological figure, because it is not tethered to a grounding model. As Camille so succinctly explains, the simulacrum is "based upon the premise that images do not so much replicate the real or substitute for it but rather are encounters with another order of reality entirely" (Camille 1996, 40). We need, though, to take this one step further: the simulacrum is an encounter with another order, but we may not want to call it another order of reality. The direction in which the phantasmatic simulacrum is pointing us, as it illuminates the animatic apparatus, is toward a domain in which images—even where they explicitly play with forms of representation of all kinds—have left the realm in which a reality principle holds sway.

There is no death in animation, because there is no being—no existence—to begin with. There are no necessary limiting features, no essential finitude—everything is shadowed by its possible metamorphosis, erasure, and resurrection—and there is thus no ontology. This is what Daffy Duck teaches us, and learns himself, through his harrowing travails in Chuck Jones's 1953 *Duck Amuck*. In *Duck Amuck*, Daffy Duck is subjected to a relentless ontological deconstruction. Anything and everything that could be imagined to tether his being to an ontological ground—his body, its shape, color, costume, and style, and particularly importantly, his voice—is taken from him by an absent "director"

hell-bent on reminding him of his ceaseless production by pencil and voiceover and the always existent threat of his metamorphosis or erasure. We first see Daffy Duck in a swashbuckler, telling his musketeers to stand aside as the enemy "samples his blade," but as Daffy stabs forward with his sword, the background scenery disappears, and we find ourselves in the void of a blank frame. The scenery returns as a farm. Momentarily put out, Daffy quickly adapts to his new surroundings, appearing in overalls with a hoe singing *Old Macdonald* (or, rather, "Daffy Duck, he had a farm..."). But just as Daffy settles into his new routine, his surroundings metamorphose again, and he finds himself in an

arctic landscape, complete with igloo. The background transformations stop—but only because Daffy himself becomes the unwilling object of the morph. His body is erased and redrawn in multiple ways—at one point an almost psychedelic parti-colored Daffy walks on all fours and has a flag for a tail. Just when it seems that the voice may be his one constant and ontological anchor, it, too, is stolen from him. When he opens his mouth to speak, there is silence, followed by a cock's crow and a monkey's call. This particular assault provokes Daffy's characteristic, "I have never been so humiliated in my life!"

A number of other mutations involve the cartoon's animatic coordinates. The medium itself appears to turn against Daffy, contesting his existence at every twist and turn. The top of the frame falls on Daffy like a stage curtain coming undone. The film strip begins to roll, and his image is doubled, with one Daffy in a frame above and another in a frame below. The subjective insult of his very reproducibility leads to an antagonistic encounter between the two Daffys. Finally, at the end of his last nerve, Daffy asks, "Who is responsible for this? I demand that you show yourself!"

At the end of *Duck Amuck*, we do in fact discover the hitherto invisible source of Daffy's humiliation. Now, if we found, say, Chuck Jones himself (as in early animation, where the animator so often played a role in his own work), one might argue that the ontological anchor of the animatic image is the animator. But here we rather discover Bugs Bunny, sitting at a drawing table with the Daffy cartoon lain upon it—"Ain't I a stinker?" he says in his characteristic drawl, casting this ontological deconstruction into the abyss, that is, enacting it as a mise-en-abîme, and insisting that behind a cartoon is always another cartoon.

What *Duck Amuck* stages is thus the an-ontological nature of animation as a medium. Rendering enters an infinite regress. Of course, this cartoon has a very specific cultural location in the America of the 1950s—in this case, the object it needs most to deconstruct to reveal its an-ontology is the animal character that provides its typical anchoring—but it also enacts what I'm arguing are the essential characteristics of the medium itself.

The Fleischer Brothers' (*Koko's*) *Cartoon Factory*, in which any character may animate or inanimate any other, makes this same point by means of an even more thorough appearance-dispersion of life. The cartoon opens with Dave Fleischer drawing and animating Koko the Clown. In one segment, Koko builds a toy soldier. The toy soldier comes alive, in this case, live-action live, only to draw and animate other soldiers, who come after Koko.

As quickly as they come, Koko erases them with his animating-and-inanimating machine. The animatic body is made from scratch, coming into being with the line or pixel. Its play of animation and inanimation exists on a continuum and emerges from the feedback loop of light, hands, technics, voices, etc. that coordinate its production.

William Schaffer offers us a useful way to think how the technicity of animation produces this metamorphic, an-ontological body. He characterizes the an-ontology of the animatic body as a mode of virtuality. That is, the animatic body never exists, because it is always in a process of coming into and passing out of existence. Drawing on the single paragraph devoted to animation in Deleuze's *Cinema 1: The Movement-Image*, Schaffer explains that a fundamental difference between the cinematic and animatic apparatuses is that while in the former, the time of capture and the time of projection coincide, in the latter, they do not. While both function via any instant whatever of twenty-four frames per second (or of any variant frame rate), animation is characterized by the difference in the temporality of production and projection. The animator or animators must engage with each frame, and one frame can take an hour or a year to produce.

This difference in temporal structure has definite consequences for cinematic bodies and, most importantly, for our purposes here, for animatic ones. Schaffer writes: "In cinema, as Deleuze argues, the automatic interval allows cameras to extract movement from bodies, even if it then decenters movement by raising to a plane of immanence opens to effects of false continuity. In animation, the automated interval engenders movement" (Schaffer 2011, 460). The animatic body—always virtual, coming into and passing out of being without ever inhabiting it—is produced via "a circuit of self-affection played out in time between human and machine" (463). Its production emerges from the circuit of hands, eyes, voices, light, and camera that feed its process of emergence. The

animatic body is divided against itself in time and engendered via a machine, to tilt Schaffer's perspective a bit, composed of human and technological "parts," functions, and rhythms. We can see how the virtuality of the animatic body shifts the already unstable oscillations of cinematic life. It brings us back to the zero degree of the beam of light, or the blank page, or the white or blue screen as it encounters the animatic machine. There's an active void, and a gesture, and it begins. Anything can be erased, but it can also always be resurrected. Cartoon style violence is a case in point: if a head hit with a frying pan assumes the shape of a pan, it takes only a moment to bounce—or squash and stretch—back to its usual proportions. This particular tradition obtains particularly in the American cartoon, of course, but just as time, decay, and death always shadow the living picture of the cinematic image—even where the particular content of the text would absolutely belie any and all of these—in the same way, the possibility of metamorphosis and resurrection always shadows the animatic image. However, the metamorphic flexibility afforded by animation's an-ontology always also includes a variety of limiting forces, drag coefficients, and repetition compulsions that produce the appearance of static figures.

Here is where the cultural logic of animatic life figured by the doll dovetails with the medio-logic of animation: it doesn't begin with genealogical succession (or a pro-filmic real), but with a blank page or blue screen or beam of light as these encounter the animatic machine and unfold into a play of gestures and metamorphoses. Although the blank page/blue screen/beam of light are signals of animatic potentiality, this must always encounter and engage the particular limits of the circuit by which it is engaged, as I will explain in more detail below, as well as whatever repetition compulsions this circuit includes and plays out.

The limiting factors and repetitions can take different forms: One of the possibilities moving-image animation deploys

most often involves reproducing the cinematic reality effect via animatic means. In certain instances, this may come across as a transmedia mimicry. In others, its simulation of cinema constitutes a commentary on it, as well as a kind of opening of the cinematic to other dimensions and possibilities. One of the distinctive features of the history of moving-image animation is in fact its particular relation to representation. Where animation figures, it also produces a theory of figuration. Because it has no necessary links to the real spaces and times of photographic media, where it chooses to represent aspects of a "real" world, it has to build from the ground up, thus implicitly thematizing whatever codes of realism it chooses to deploy (or to subvert). One could say this of any non-photographic medium, but animation's specificity lies both in its material movement in time and its historical connection with cinematic representation. Together, these construct its very particular relation to modalities of "realism." Of course, conventions within animation itself have developed in different genres and national traditions of animation, and where these are used without comment, they also become "invisible." But because of the infinite possibilities of animatic figuration, animation has a unique ability to comment on conventional codes of figuration and representation, as well as to reflect upon the existential, perceptual coordinates they conventionally represent.[3]

Animation as Allegory

Unlike live-action cinema, where the time of capture and the time of projection must coincide, animation opens up an "interval of control" on the side of production. In the history of animation, the almost infinite possibilities for manipulation quickly lead to a division of the labor of production and turn animation into an industrial art par excellence. As William Schaffer describes animation's "paradox of control": "the process of animation necessarily involves the opening of a kind of feedback loop

circuit between existing models for the possibility of movement, the automated interval and the collective network of bodies and brains formed by animators themselves" (461). It is perhaps not surprising, then, that the animatic apparatus so often allegorizes its conditions of production, taking as its subject the life humans live in concert with machines and the new forms of life born from this conjugation.[4] (This applies to digital cinema, of course, but also to even the most primitive of special-effects films.)

Animation's "control interval" gives it a special relationship to the disposition and modulation of perception. It can both enact perceptual modulations and picture them all at once: Unlike photography, animation doesn't have any necessary indexical relationship to a real world. It can be completely abstract and non-figurative.[5] When it does produce a representational scenario, however, it does so by copying the conventions of realism, typically the conventions of cinematographic realism. Because it must always produce its realist effect by hand (or pixel), all animation is always a meta-discourse on the conventions of realist representation.

To put this most starkly: where it figures it is at the same time a meta-commentary on figuration. It's always showing us its own construction of perceptual verisimilitude. As animation scholar Paul Wells suggests, "Animation does not share the same method and approach as the live-action film. Rather, it prioritises its capacity to resist 'realism' as a mode of representation and uses its various techniques to create numerous styles which are fundamentally about 'realism'" (Wells 1998, 25). Even in animated films that strive for realism, the codes by which they do so remain highly legible. When Disney uses more sophisticated plane cameras to create depth effects in *Pinocchio* in 1937, for example, its clear aesthetic references are German Romantic painting and the cinematic depth of field made possible by the faster film stock and more sensitive lenses developed earlier in the decade.

Chapter 6

Animatic Aesthetics, Part 2: Affects, Anagrams, Simulacra

Where *Duck Amuck* gave us a streamlined 7-minute version of animatic an-ontology in the familiar fancy of the Warner Brothers universe, *Innocence* scatters and proliferates its own auto-theoretical investigations across 100 minutes of complex plot and a philosophical dialogue on artificial life. The very cultural conditions of possibility for the production of such a work — that is, of a deeply philosophical manifesto on contemporary mediology in the form of a hybrid drawn and computer-generated animated narrative — themselves point to a number of features of animatic culture, including its global dimensions and the way it thinks its own technicity.

The figure of the doll is an index for aesthetic and philosophical concerns with modern spectacular culture, the emblem for the animatic apparatus at the moment that it moves from a minor tendency within culture and media to its dominant mode. And if we follow this figure, we can see that the doll comes to crystallize the functions of a very particular kind of image — an affective, productive image, a simulacrum in Deleuze's sense — that shifts the very terms of the question of the image: rather than inquiring into its relation to the real, it asks what new territories may be opened up. Its residual resemblance is a kind of skeuomorph — an archaic design detail maintained in the interest of user friendliness, so that the new isn't without all familiarity. The radical possibilities that come directly from biotech, those explored by Mitchell in his investigations of the age of biocybernetic reproduction, materialize the stakes of this version of the simulacrum. This horizon of thinking the "human" or thinking "life" demands an acknowledgement and

exploration of their ontological instabilities and their forms of difference, the novel modes and forms of inhuman or non-human or extra-human life. The coalescence of animatic forms of media production with the emergence of a new form of affect capitalism implicates the image-attention nexus and the structuring of perceptual experience in this same constellation.[1]

In another interview, Oshii explains that in *Innocence*, by exploring the world "from the doll's point of view," he hopes to shed some light on a few of its illogical features—from violent crime, to "a culture of fear and anxiety," to the fact that we make dolls, automata, and even industrial robots "in our own image." Pointing to the apparent paradox of the dolls' simulacral nature—constructed in human form and yet consistently identified as constitutively in-human or non-human, he says, "The movie does not hold the view that the world revolves around the human race. Instead, it concludes that all forms of life—humans, animals, and robots—are equal. In this day and age when everything is uncertain, we should think about what to value in life and how to co-exist with others... Humanity has reached its limit" (Cavallaro 2006, 208).

Innocence cultivates an inhuman perspective and, as indicated by the close-up on the doll's eye that ends the film's credit sequence, asks us to see with the eyes of a doll. The world that we experience in *Innocence* is not our everyday human landscape—at least, not as this landscape is homogenized and naturalized by a perceptual realism, cinematic or otherwise. Individual shots are composed in more than one style; the space is mixed and hybrid, rather than continuous. The film combines extremely detailed photo-realistic elements, typically in the rendering of its backgrounds and often using CGI and 3D effects, with a highly stylized, almost flat, hand-rendered style more often used for the characters, which can sometimes be almost stripped-down hieratic figures: Oshii's human (or part-human or almost-human) figures thus explicitly repel conventional forms of identification,

conjuring a kind of subtle disturbance in the spectatorial field. Oshii actually cultivates disturbances in continuity too. He changes the key animator from scene to scene, depending on the feeling he wants to cultivate.

This mixed-space effect is only intensified by the number of computer and tele-screens of all kinds that appear in the film, as well as by the presence of Batou's visual field. He doesn't so much see in a visual sense as scan the world as information: scenes are shot through with graphs and data fields. In addition, Oshii rarely takes the typical, perceptually stabilizing approach of making the camera level with the human eye. He works with extreme high and low angles, tilts, deep focus, and so on. Throughout the film, the spectator experiences a kind of disorientation. Even if we can't quite pinpoint the subtle shifts in tempo or point of view, we sense an insistent artificiality that disrupts a coherent visual space.

This artifice and disorientation reflect back on the apparent naturalness of everyday perception. We imagine perceptual space to be coherent, despite the fact that our constant engagement with images and screens of all kinds has us entering and exiting a wide variety of perceptual worlds daily, even hourly. Our perceptual space is always mixed, composed of a wide variety of texts, of audio-visual elements and styles, of graphs and other dispositions of data. If we continue to read these effects as reflecting on the perceptual (dis)orientations of the contemporary world—at least the world of the high-tech metropolis—Oshii shows us how much of our vision and our affective experience is already inhuman, or rather, engendered by the life we live in concert with machines. The doll is other and the doll is us.

The animatic apparatus is implicated, as one historical instantiation in this quasi-transcendental (or at least trans-historical) postulate on the non-nature, or second nature, of the species. Our interiorizations of the spatial and temporal

forms of media produce our future modes of perception.[2] The ramifications of this, as Oshii pictures them in *Innocence*, are that in advanced techno-scientific societies, the maps are so complex that the human is not at home in its world. Spatial and temporal experience, increasingly generated by an engagement with the machine world, is profoundly disorienting.

While Oshii cultivates novel sensations, he does not work toward the "immersion" that is the contemporary hallmark of visceral style. His is a more subtle kind of animatic affective poetics—one that plays with extreme shifts in scale and register, with hybrid spaces, with anagrammatic reconfigurations, and with perceptual disorientations that push a spectatorial realignment. My use of the terms "poetics" here is motivated by the film itself, which refers to several literary texts that are known for their unusual compositional principles—including Raymond Roussel's *Locus Solus*, as well as a hybrid work of literary and photographic anagrams, *The Doll*, by the German Surrealist Hans Bellmer that I will discuss below.[3] Oshii's film takes up the trans-medial possibilities of these poetic processes. In addition, I argue that non-narrative interludes—as well as infra-narrative elements—in the film work in an ekphrastic, enargeic mode, and by this I mean that their function in the film is to produce affective states, or states of feeling—particular types and configurations of vividness—as spectatorial modes. *Innocence* produces perceptual cues that thus may call on—or even force—the spectator to synthesize this affective information in novel ways, or, on the other hand, may work to block a full perceptual, emotional synthesis.[4]

While I have so far emphasized the figure of the doll and thus the positive, even utopian dimension, of the film, Oshii's story unfolds against a backdrop of corporate greed, governmental corruption, environmental degradation, and individual alienation and anomie. The characters almost never speak directly to one another; there are rarely eye-line matches, and figures are

typically staged as occupying separate domains, even within a single frame. While all of the characters can literally "plug in" to the communal dataworld of the net, the experience never feels collective. Each one exists in his own monadological space-time bubble, dis/connected to and from the world via wires, screens, and other interfaces—much like Mitchell's treadmill subject, complete with iPod and biofeedback systems.

Despite Oshii's diagnosis of the spatio-temporal disorientation, he doesn't see the answer as a return home. He pushes, in fact, on its very unhomeliness as a platform for experimentation. The next sequence that I will discuss follows Batou and Togusa to the Northern Territories to investigate the factory ship on which the company manufactures the malfunctioning gynoids. The Northern Territories are a kind of wild frontier, a no-man's land where the UN and the e-police have no jurisdiction; Locus Solus has its operations there to avoid regular legal controls. While there, they go to the mansion of the master hacker, Kim, an old contact of Batou's with ties to Locus Solus. The modus operandi of this sequence is its destabilization of all of its perceptual coordinates. This plays out in terms of: relations of scale; speeds and slownesses; types of depth, detail, and ornamentation versus types of flatness, abstraction and two-dimensionality; disruptions of boundaries between interiority and exteriority; uncertainties about the boundaries and autonomy of objects; and uncertainties regarding life and death, animation and inanimation.

We first encounter Batou and Togusa in the shadow of an enormous statue on a kind of tiled island with a pathway that stretches over still water to the door of the mansion. They are tiny figures next to an enormous figure of a foot (its plaque reads "homo ex machina") and between a huge, cloud-filled sky and its reflection in the water. It's not just that we feel the smallness of the human characters and the enormity of the landscape; it's that each element in the scene seems to exist in its own space,

apart from all of the others. The foot statue no more goes with the tiled path than the size of Batou and Togusa matches the scale of the landscape. This kind of separation of objects is specific to animatic technique, where a scene can be built from multiple layers.

As the two walk across the long, narrow path, their pace seems almost impossibly slow; time expands to match the void opened between the moving clouds and their reflections. And then snaps out of joint: the rate of movement of the clouds and of the camera in the POV shots is very apparently at odds with the pace of their walking. Two completely different temporal modes are thus operative at the "same time" and within the same space. The cut away to the side view then shifts into a different visual style, flatter, more simply rendered.[5] The scene pulls apart its elements, both spatial and temporal: their relations are awkward, noncontinuous, "inorganic," and this, in turn, forces a perceptual disarticulation. The resynthesis of these audiovisual elements comes at the price of orienting oneself to a chronic and shifting disorientation.

The opening doors lead us into a music box, one legendary home of the doll, and the echoing of the music reinforces the sense of inhabiting its interior space.[6] As we follow Batou through the mansion, our perceptions are pulled apart by its surprising juxtapositions: a dining room opens onto a sky, static hologrammatic pigeons are accompanied by the sounds of live birds. Even shadows are detached from objects that would cast them, like the shadow of a hand opening a door in an empty corridor and the shadow of a runner with no body to cast it. Like the moment at which the carnival masks multiply, these juxtapositions conjure an aesthetic that refers back to the digital mode of their composition. In the example of the frozen hologrammatic birds accompanied by the movement of birdsong, we feel the separation between the image track and the sound track. Sounds don't emanate from bodies; they are

juxtaposed, superimposed, layered. While the scene shares some of its effects with Surrealist collage, it possesses new coordinates that pertain to the compositing of digital aesthetics: in addition to the divergence of image and sound, each visual or aural object is always movable, transportable, reusable.

Apparently bounded and stable objects open into new worlds. Togusa spins a globe, and its landmasses and oceans turn into the faces of animals: bassett hound, monkey, bird. He looks into a miniature, doll's house version of Kim's mansion, and is sucked out through an aperture, back onto the statue island. We are never sure which entities might be living or "biological" as Batou's vision charts it, or, on the contrary, inert, or robotic. I have already noted the presence of Batou's unique visual field in the film. We have to question, too, what kind of "vision" is involved in Batou's POV shots where we see a computational monitoring and scanning of spaces and objects. Given that Batou does not exactly have eyes, but rather implanted lenses that interface with the monitoring, scanning, and analysis accomplished by his cyborg brain, do we know this is vision per se? Is it in fact optical? Or could it be more like a sonogram or

MRI, non-optical waves that produce a visual image? Sensory data and computational processing meet and interchange, with or without the intercession of human consciousness.

Anagrams and Simulacra

The final scenes of this sequence—as well as some of the film's broader aesthetic and conceptual concerns—emerge from Oshii's engagement with Hans Bellmer's work. Bellmer was a German Surrealist artist who first turned to doll making in the early thirties as a rejection of fascism, and of all productive activity. His first series of doll photographs was privately published as the book *Die Puppe* in Germany in 1934. It is Bellmer's second series of photographs in particular that inspires Oshii; Batou even leafs through an edition in a scene in the film. For this series, his most famous, Bellmer constructs "a kit of mutually interchangeable parts: one head, two pairs of legs, one pair of arms, one plain torso, two pelvises, a torso with four breasts and another with curious folds around its waist, and a central ball-joint (that formed the belly)" (Bellmer 2006, 17). Each of the photographs—he produced more than one hundred—is

of a different permutation of these elements. The bodies thus produced appear disturbingly de- and re-articulated. A head literally rests on a shoulder, a vulva is tucked under an arm, two pairs of legs stretch in opposite directions from a single torso. Bellmer constructed the dolls himself, but it was his photographs of them along with an accompanying text (rather than the objects themselves) that he intended for exhibition and publication.

Much has been written about these provocative photographs,

and it is impossible not to be struck their de- and re-formations of a doll body very insistently gendered female. While early criticism often remarked on the apparent misogyny of these de-articulated female images, more nuanced criticism has noted the possibility that the gaze conjured by the dolls is not necessarily an aggressive voyeuristic one, but rather one that also involves a call to identify with the doll's plight. Texts by Hal Foster and Rosalind Krauss reflect on this problematic in interesting ways, but the most persuasive diagnosis is offered by Laura Frost, who suggests that the mechanics of spectatorship they deploy are similar to those deployed in slasher films, as Carol Clover describes: we identify with both subject positions, with villain and victim (Frost 2001). This diagnosis is also most consistent with Bellmer's own theories of bodies and desire, where desire involves a phantasmatic taking on of the other's body, a layering of body images of both sexes (in a heterosexual context) in what Bellmer call the "physical unconscious." He describes this phenomenon, along with others, in terms of "mobile interoceptive diagrams, each traced atop the others" (6).

Both Bellmer's writings and his dolls describe and enact his theory of a surreal and metamorphic embodiment, an alternatively affective and transformative body that shadows the everyday, massy, anatomical one. Bellmer clearly draws on the work of the Austrian psychiatrist and psychoanalyst Paul Schilder in his own writings (though it remains uncited) to develop his conception of the physical unconscious. It is in this space of the physical unconscious that the body, or to use Schilder's term, "the body schema," is continuously altered and reformed. It's worth looking at Schilder's fascinating work directly, at least to draw out the features that can help us understand Bellmer's work.[7] According to Schilder, the body schema is always in transition: "It is not a structure but a structuralization" (Schilder 1950, 20). It is synesthetic. "In the scheme of the body, optical, tactile and kinesthetic impulses can only be separated by artificial

means" (21). The body schema is also always intersubjective and intercorporeal, according to Schilder. We take in parts of others' body schemata and project parts of our own. It is social and historical, potently connected to cultural and familial forms as well as psychic fantasy. One of the important characteristics of Schilder's body schema is the manner in which it reworks notions of the cultural image repertoire (like Jacques Lacan's "gaze" and "screen") in relation to modes of habitual, tactile practice. The body schema is always prosthetic, incorporating things of various kinds. In order to use any tool, for example, we need to incorporate its size, weight, and motion into our "body schema." Schilder quotes the neurologist Sir Henry Head: "Anything which participates in the conscious movement of our bodies is added to the model of ourselves and becomes a part of these schemata: a woman's power of localization may extend to the feather in her hat" (24). Our encounters with media of all kinds are likewise attuned to our body schemas. He writes of our pleasure in watching a contortionist as "based upon our wish to break through the borderlines of our own body" (25), and of our constant experimentation with these contours.

As the title of Bellmer's book, *Little Anatomy of the Physical Unconscious, or The Anatomy of the Image,* indicates, the anatomy of his own conception of the body schema, which he calls the physical unconscious, is intimately bound with that of the image. Bellmer describes the image as always double: a "projection screen" upon which interior impulses and inclinations encounter an element of the external world, and vice versa. Subjectivity and objectivity are turned inside out, as it were, in the anatomy of the image. Bellmer thus sets up a very explicit relay between the human body, the doll body, and the body of the image. "The body," he writes, "is comparable to a sentence that invites you to disarticulate it, for the purpose of recombining its actual contents through a series of anagrams" (37–8). Bellmer produces textual anagrams, doll-body anagrams, and as we see in a variety

of illustrations in *Little Anatomy,* anagrammatic permutations in the physical unconscious itself. The shifting elements of the anagrams entail shifts in perception. Bellmer also describes the image as always a "representation-perception image," where the degree of discordance between the sides of the image (subjective and objective) produce greater or lesser intensities of shock or delight, that is, different affects. Unsurprisingly, Bellmer's art was declared degenerate by the Nazi regime, and he fled to Paris in 1938.

As I mentioned above, in a scene of the film—and one which will direct Section 9 toward Locus Solus—Batou flips through a book featuring a cover image by Bellmer. As this image was used on the cover of Peter Webb's *Death, Desire, and the Doll: The Life and Art of Hans Bellmer,* it is quite likely that Oshii knew more of Bellmer's work than just the doll photographs. Oshii flew members of his crew to New York City to see an exhibit of Bellmer photos at the International Center of Photography as part of the preparation for the production: These ball-jointed dolls are the visual model for the Hadaly model gynoid.

Oshii's Bellmer-model dolls are never subjected to the kinds of permutations that Bellmer's own were, however: It is the film as doll, the body of the film itself, that undergoes anagrammatic treatment. The scene of this visit repeats four times, and the first three are direct anagrammatic permutations of one another. For example, when we enter the mansion's "music box" foyer in the first scene, we see, suspended from the ceiling, a wire figure of a kind of insect-like bird. In the second version, this becomes a mechanized *Winged Victory of Samothrace*; in the third, it will become a seagull. In the foyer, a doll with a dog spells out words and numbers with tiles, first "aemaeth," then "maeth," and then "2501." The identity of the characters also morph and transform in a variety of ways. In the first scene, Kim at first disguises himself as a corpse. In the second, Kim assumes Togusa's form and Kim as Togusa appears as a marionette. In the third, Kim

appears with Batou's mien, which at the end of the sequence springs open to reveal gears underneath. Although Batou and Togusa finally escape the anagram (amid a sea of explosions), and the repetitions are explained (Kim had hacked into Togusa's e-brain), it's clear that no real stability or coherence can hold sway in the face of these metamorphoses and permutations.

Along with the film's anagrammatic construction, the sequence's central features are its deployment of conventionally uncanny figures and its multiple discourses on the "artificial"

human. We see living and dead, vital and mechanical, natural and artificial meet, interpenetrate, and exchange. This takes place on the level of the film's dialogue as well as in its montage construction. In each scene, a quotation (or a paraphrase) is put into the mouth of the morphing figure of Kim. The first scene quotes Kleist's "On the Marionette Theater," the second ventriloquizes Freud's essay on the uncanny, as we will see, and the third refers to the legend of the Golem, which already had appeared in the music box permutations: a figure from Jewish folklore, the Golem is a man made of earth or clay who may be animated by placing a small piece of paper with the word "aemeth," (a version of) the Hebrew word for truth, in its mouth. It may be de-animated by removing the piece of paper or by removing "ae" to produce the word "maeth," or "dead."

Each scene thus presents another permutation of characters' bodies in tandem with permutations of the discourse on the simulacrum. The first monologue is declaimed by Kim as corpse, but even this body is a hybrid cyborg-android-marionette. When Batou reveals the ruse, the first thing out of Kim's mouth is strange mechanical laughter. After a short exchange with the detectives, he says this about the Locus Solus dolls and his own strange form, combining Kleist's puppet with Shelley's skylark and a Confucian epithet on death:

The human is no match for a doll, in its form, its elegance in motion, its very being. The inadequacies of human awareness become the inadequacies of life's reality. Perfection is possible only for those without consciousness, or perhaps endowed with infinite consciousness. In other words, for dolls and for gods... Actually there's one more mode of existence commensurate with dolls and deities. Shelley's skylarks are suffused with a profound, instinctive joy. Joy we humans, driven by self-consciousness, can never know. For those of us who lust after knowledge, it is a condition more elusive than

godhood... Without knowing life, how can we know death? That's what Confucius says... but death is a precondition of life for a doll.

He continues this thematic into the second scene, where he adds Freud's uncanny into the mix, along with some thoughts of his own:

The doubt is whether a creature that certainly appears to be alive, really is. Alternatively, the doubt that a lifeless object might actually live. That's why dolls haunt us. They are modeled on humans. They are, in fact, nothing but human. They make us face the terror of being reduced to simple mechanisms and matter. In other words, the fear that, fundamentally, all humans belong to the void.

These hybrid passages do not so much provide a coherent treatise on the simulacrum as they offer food for thought. The human is clearly placed at a disadvantage here, deprived of the doll's elegance and its knowledge of death, as well as of the skylark's pure animal joy. Unlike these other figures, who possess superior states of knowledge and sensitivity, the human is foiled by vacillation, possessed by intellectual uncertainty, and terrified by the openness of its own ontological situation. The doll's difference has been maintained so insistently through the film that the final sentences above can be read only in this way: by making the doll human, they thus make the human simulacral. If both the doll and the human emerge from the void, they have a nonessential relationship to origins. They have no vocation and no destiny. To return to Deleuze's formulation, the exterior resemblance is the result of internal difference; what is the same is difference itself. In the domain of the simulacrum, "it is resemblance that speaks of interiorized difference, and Identity, of Difference as a primary power." As Brian Massumi

explains, "The resemblance of the simulacrum is a means, not an end… Resemblance is a beginning masking the advent of whole new vital dimension" (Massumi 1987, np).[8]

The doll here disturbs any stable ontology and opens up a new territory for exploration and experimentation. Rather than attempt to reestablish boundaries and to find a home for the human, Oshii engages in a kind of poetic play with its reconfiguration. The anagram is a response to the an-ontology of the doll: it is a mode of invention and recombination. Oshii develops this as a means of remapping and remaking the doll body of the film—and that of the spectator. The doll, the human, and the film—"living images of perpetual motion"— all become available for transformation. Oshii substitutes for a determination of the who and the what, for answers to questions of categories, a kind of how—a set of operations that constitute an ethics and a politics as much as an aesthetics. The power of art—in the midst of the highly industrialized global corporate technical system that *Innocence* pictures, that is, in the age of biocybernetic reproduction—is to produce different maps, different experiences of space and time, different means of navigation. And in this sense, different forms and modes of bodies and of life.

Oshii's Animatic Body

Between *Ghost 1* and *Innocence*, Oshii also undergoes a kind of crisis or conversion experience that highlights his own engagement with an animatic, metamorphic, transforming body. He says:

The message of this movie is your body. As I got older, nowadays, I make a film that is good for my body, but before that I used to make a film only using my brain. When I made the first *Ghost in the Shell*, I thought about what really makes your body your body… The conclusion I came to at the time

80

was your brain, and more specifically, your memory of life. When I made *Ghost in the Shell 2*, my conclusion changed. This time I thought it's your body, and it's not anything specific, like your arm or your leg, it's the body as an entire [entity], and more than that, it's really the relationships you have with other people (Gilchrist 2004).

Oshii has had a lot to say about "the message of this movie." It's about humanity from the doll's point of view; it's a critique of anthropocentric humanism; it's about "your body... and more than that... the relationships you have with other people." It hardly needs mentioning at this point that we need to take "people" in the most expanded sense here: Batou himself is almost a complete cyborg, and his closest connections are to his basset hound, Gabriel, and to his former partner, Major Motoko Kusanagi, who merged into the net at the end of *Ghost 1* and returns at the end of *Innocence* — assuming one of the bodies of the Hadaly dolls, no less — to help Batou win his battle on the Locus Solus ship.

In addition, in the alienated social world of *Innocence*, with its lack of eye-line matches and its monadically imagined characters, each one in her own space-time bubble, there are connections — and these are at the center of Oshii's own imagination of what the film does, of its affects. Where *Ghost 1* ended with the omniscient net, *Innocence* leaves us with conjugated bodies, bodies in relation. Just as the concept "people" is reoriented and expanded in the film, so too is the concept of "body," which may be a human body, an animal body, a doll body — or some combination of these. In the final scene, we have images of a series of pairings: the cyborg and his dog, the father (Togusa) with his daughter, the daughter with her doll...[9] The film is interested in the power of these different modes of connection, which, Oshii suggests, here actually compose a body in a "good" way.

The comparison contained in the second sentence of the quotation above is instructive in its unusual shift in register: "As I got older, nowadays, I make a film that is good for my body, but before that I used to make a film only using my brain." The first film prioritizes an epistemological inquiry into the brain, into memory and subjectivity. The second film, Oshii suggests, isn't about knowledge or subjectivity, but about the effects the film has and the affects it can generate, particularly in terms of it being "good" for the body. This returns us to Bellmer and Schilder's territory, where the image both reacts to and transforms the body schema, where the body schema is in fact a part of the image's double structure. Oshii explains that he makes the film as a kind of ethico-aesthetic therapy. If the first film questions the meaning of "ghost," the second displaces the question entirely. The doll shows us, in Kim's words, what we don't want to see—that the human "belongs to the void" and that the ghost, too, is inessential. But it is precisely this open, unstable zone that, for Oshii, engenders potentials for novel conjugations and sensations. Here, affect doesn't wane, but rather intensifies and alters in conjugation with the new forms of life emerging and circulating across domains.

Chapter 7

Animatic Pop: Body-as-Image, Image-as-Body

If *Duck Amuck* provided a kind of distilled, eidetic version of the life logic of animation, and *Innocence* intensified and proliferated it, it still remains to establish where and in what ways we see manifestations of the virtuality and an-ontology of the animatic apparatus operating in contemporary culture. In Chapter 1, I established the coordinates for the cinematic image and the cinematic body; here I'll look at exchanges between animatic images and animatic bodies. Where cinema—and the cinematic-biopolitical regime—is structured by a distance between the screen body and the spectator's body, the animatic apparatus, as we'll see, always tends toward merging and exchanging image space and body space.

The first section briefly considers the use and thematization of animation in contemporary advertisements. The second looks at new, virtual life forms that jump the assumed ontological cut between media space and body space. The third examines the virtual and technical dimensions of the biological human body as they are conceived in a narrative of gender transition. This chapter functions both to expand our gaze onto the manifestations and meanings of the animatic apparatus, and to set up the coordinates that will allow us to engage the question of an-ontological ethics in the Conclusion.

Prelude

Advertising and celebrity culture are often the most direct pipelines into at least a certain dimension of the cultural phantasmagoria, and here they help to illustrate animation's medial "life." In online auto insurance company Esurance's

"get animated" series of commercials, the nature of animation is presented quite simply. The real Esurance customers who are chosen (now via talent search) to undergo this an/ontological metamorphosis are, after their animation, slimmer, more attractive, more mobile, and faster. Shown in the beginning of the flash shorts as their real-life, modestly attractive but not celebrity-ideal selves, they are transformed by animation's mobile lines. In that form they save time, they save paper, they save trees. (Many of Esurance's animations include an ecological pitch. Go virtual, they say, save the environment.) Esurance's newly animated customer-characters whisk through work and play actively with their cartoon kids. Their bodies no longer have to encounter gravity's forces, or any material resistance for that matter. One online comment reads "to be hot you don't even have to be pretty anymore, you just have to 'pop' in an exaggerated way like a cartoon character."

In another context but a similar vein, the social-networking site Facebook advertises a partner site where you can "animate yourself," which in this case means having a photo transformed into a cartoon caricature. Getting "animated" replaces being "discovered"; Adorno and Horkheimer's shopgirl now dreams of becoming an animated character rather than—or along with—a movie star. In the former scenario, the paradigm of "discovery" maintains an existence that precedes becoming-spectacular, and continues to haunt and inflect the dream-factory version. In the second, the crucial feature is that she receives the tools for her transformation into another form of life. The distinction marks a change in cultural logics.

It would be absurd to say, however, that there are no longer bodies to be invested. It's rather that the body has become a way station or site of transformation (rather than a final reference point). The ontological questions posed by the relay of bodies in *Intervista*, along with Ekberg and Mastroianni's nostalgic gazes, are replaced by the celebrity surgery spread where

tabloid speculation asks: scalpel or photoshop? The multiple plastic surgeries of reality TV stars work to embody the animatic "pop," to remake it in sculpted flesh and silicone, Botox and Restylane. The transformation is the story. Heidi Montag, who underwent ten different plastic surgery procedures in a single day, was working to look like an ideal, a doll, and succeeded in her task (though she later expressed regret at having undertaken it). The goal of these surgeries isn't the one associated with a vast majority of plastic surgery's popular variants. It isn't conformity, enhancement, or even optimization or perfectibility. It's another kind of transformation entirely. The form of life that it pertains to is different—and what is distinctive about the contemporary moment is that way the old form is sliding into the new. Where Sobchack diagnosed cinema's coalescence with the older cosmetic surgical logic, here we can see its plastic, animatic twist.

A general public outcry of shame and disgust is part and parcel of the enormous amount of media coverage given to the biomedical aesthetic manipulations of Montag, as well as to the suspected metamorphics of celebrities such as Kim Kardashian and others, not to mention the Octomom Nadya Suleman, whose combined plastic surgeries and IVFs have revealed the strange complicity—or implicitly—between what may seem on their surface very different biomedical domains. Suleman not only remodeled her face and body to resemble Angelina Jolie's, but also, upping the ante on Jolie's brood of six (three adopted and three biological) children, had fourteen biological children. While the number itself may not be extraordinary in the broad scope of human history, this hyperdrive-animatic version of reproduction (the exact number of embryos transferred in the case of the octuplet birth has never been publicly released) is of course dependent on the combination of novel biotechnological possibilities and a novel (and apparently not entirely idiosyncratic) understanding of family planning. The discourse of "ethical

failure" in the popular response to these examples continues to vacillate between a valorization of the body "intended" by god or by nature and a denigration of the grotesque. It explicitly advocates a return to a body as reference, a body grounded either in nature and biology (these are sometimes more or less interchangeable concepts in this context) or in theology. Putting aside whether or not, in any particular case, the ethical censure is warranted, it lacks critical force in the face of the animatic logic that subtends both the pop cultural and biomedical operations here, as both eschew, to use Franklin and Lock's terms, both "genealogy" and "the grid of a single, unified system" — that is, all attributes that could provide ontological ballast and stability for these notions of theologically or biologically essential lives and bodies — in favor of technologies "of doing, building, and engineering" (Franklin and Lock 2003, 14).

Some well-known media personalities make explicit their embrace of this change in the cultural logics of bodily transformation. Valeria Lukyanova is known as the Human Barbie because of her famous (and highly constructed) resemblance to the ever-popular toy. Her videos have garnered millions of hits

on YouTube, spurring widespread media coverage and a Vice documentary, *My Life Online: Space Barbie*. We learn from the documentary that Lukyanova believes that she's a spiritual being from another planet, and that she leads groups in astral travel. She professes that humans should shift from being animals to being demi-gods. In another interview in the film, Valeria sums up one perspective on the new logic of the animatic in a response to her critics: "It's what success is like. I'm happy I seem unreal to them. It means I'm doing a good job."

Living Images

Even before Oshii had time to make his own sequel, *Ghost in the Shell* was remade as "No Ghost, Just a Shell," a project inaugurated by French artists Pierre Huyghe and Philippe Parreno. In Parreno's "Anywhere, Anywhere Out of World," AnnLee tells the story of her life: In 1999, Huyghe and Parreno purchased a character from a Japanese character production company called K Works. She cost about four hundred dollars. They named her "Annlee." A simple stock character, Annlee was originally destined to be a background figure in a manga or an anime, one even quite likely to meet a speedy demise. That's why she was cheap. "I was never meant to survive," she says. She had none of the qualities that would have enabled her to live on as the hero of a story. The artists gave her a kind of life she never would have dreamed of.

Their first move was to strip the image, to cut away its cuteness, its *kawaii* characteristics, and create it as both alien and empty. Her enormous eyes are completely opaque, almond-shaped gray blanks. This new AnnLee, now a 3D operable model for animation, seems at once to invite and withdraw from interpretation and manipulation. In "Anywhere," AnnLee says, "I am a product, but strangely enough, I don't belong to anybody. I belong to whomever is able to fill me with any kind of imaginary material." Huyghe also made a film starring AnnLee.

And then they made more. They invited friends and colleagues to interpret, use, and invent AnnLee as they liked in film and other media. In a number of these works, AnnLee, following in the venerable footsteps of *Ghost in the Shell*'s hero, Major Motoko Kusanagi, continues to offer pronouncements on the nature of her own existence. In Huyghe's *Two Minutes Out of Time*, she says, "I am not here for your amusement. You are here for mine."

But AnnLee's glorious life as an artworld media star was always meant to be a short one. Huyghe and Parreno had purchased the character "with a poetic plan consisting of liberating a fictional character from the realms of representation" (Barande et al. 2003, 303). Finally, after a number of exhibitions in which all of the AnnLees would encounter one another, and following the sale of the exhibition itself to the Van Abbemuseum in 2002,[1] Huyghe and Parreno "freed" her, forming a company called Annlee and assigning all proprietary rights to her image to Annlee herself.

Critical reception has focused a great deal on the project's collaborative dimensions, its interrogation of copyright, and on its reconfiguration of the art world's traditional logic of exhibition. The Van Abbemuseum's purchase of an entire exhibition (which included works by Liam Gillick, Rirkit Tiravanija, Dominique

Gonzales-Foerster and many others) was a first in the history of museum purchases.[2]

But art critic Philip Nobel offers another perspective on Huyghe and Parreno's project:

No Ghost is about the limits of vitality. Why else was their first move to develop her from paper to video? From a drawing to an operable model? Why did they breathe life into her, for a time? Why did they give her random moments of experience and then take them away? Why did they contrive to save her from immortality?

"It's not a death, it's an existence," Huyghe argues. Ann will be enfranchised. We don't have a term for it. But we do now. Annlee is dead. Long live Annlee, a sign for banished signs, inaccessible, in a limbo nearly human (Noble 2003, 104).

AnnLee is an inquiry into vitality, and she did have an existence. But despite Huyghe's protestations, I can't help thinking of her emancipation as a kind of death. The limit at issue here, I'd like to contend, is not that of vitality itself, but rather of the traditional conception of autonomy that Huyghe and Parreno's liberation of AnnLee ultimately reveals. Kleist's paradox of the puppet/animator can help to illuminate this. You'll recall that Kleist positions his marionette as both autonomous and inextricably linked to the activity of its operator (who, for Kleist, must be a maker of prosthetic limbs). Kleist's maintenance of this apparent paradox constitutes one of the most important features of his theory of the marionette, and of the tradition it inspires. AnnLee exists in a contemporary version of this sphere of operations, and only within it. She gains her existence as a node in this animatic network. While Huyghe's first AnnLee film, Two Minutes Out of Time, makes this point—AnnLee has her "own" voice in the film, but is also the sonic conduit for other voices and even for the

ambient sounds of a museum visit—the "liberation" of AnnLee removes her from the ecosystem that supports her mode of life. AnnLee's death may have been necessary for the stakes of the transformation of the status of the exhibition to emerge. It also may have been necessary to reveal the paradox of her form of life. But while it's not quite a murder, it highlight's the project's sacrificial logic.

Vitality is conceived both as a property of living systems and as an experience. Conventionally these two definitions, while related, are also considered distinct in that one doesn't necessarily entail the other. But in the case of both Kleist's marionette and AnnLee what we see is the production of interoperative vitality e/affects, e/affects that are produced in systems and patterns of relation.

I've adapted the concept of vitality affects from the work of the influential American psychiatrist and psychoanalytic theorist, Daniel Stern. When Stern first theorized what he then called "vitality affects," it was in the context of the relationship between infants and their mothers (Stern, *The Interpersonal World of the Infant*). He developed this concept to distinguish a set of felt sensations of vitality (e.g. explosive, bursting, fading) from categorical affects (e.g. anger, joy, fear), and to analyze their operations. Infants, he found, well before they have stable conceptions of objects and object permanence, relate to the vitality affects of their mothers, that is, to the manners of their expressions. So, as a mother approaches her baby, the quality of her movement and affects might be flowing or leaping, and the infant experiences the dynamics of these movements. The infant's development as a subject emerges first in relation to these affects, but this is not a stage that the infant will pass through. The layer in which vitality forms operate—which Stern calls the "emergent layer"—remains one layer of a "layered self." The other layers develop subsequently, but all remain in play throughout life.

Many years later, Stern would follow up this work on human development with a work that incorporated reflections on the arts, *Forms of Vitality: Exploring Dynamic Experience in Psychology, the Arts, Psychotherapy, and Development*. Stern uses the concept of vitality forms to distinguish between what he describes as the "what" and the "how" of a movement. "Knowing the 'what' and 'why' of a movement is incomplete," he argues, "without knowledge of the 'how'," that is, without understanding its dynamic forms of vitality (Stern 2010, 20):

> Vitality forms are not empty forms. They give a temporal and intensity contour to the content, and with it a sense of an alive "performance." The content can be an emotion or shifts in emotion, a train of thoughts, physical or mental movements, a memory, a phantasy, a means-end action, a sequence of dance steps, or a shot in a film. The vitality dynamic gives the content its form as a dynamic experience. The contents, by themselves, need not conform to any particular dynamic experience. Anger can appear on the scene explosively, or build progressively, or arrive sneakily, or coldly, and so on (22).

Stern clearly establishes that vitality dynamics do not pertain only to bodies in motion. They occur in thoughts and memories and in, for example, the dynamics of a cut in a film, or in the movement of a painter's line. "Aliveness," Stern suggests, is an "emergent property" of vitality forms, and the dynamic vitality "strand" of our experience is the most fundamental and primary. In the process of perception, "the content strand takes on its phenomenal form and appears to us only when it's twisted around the dynamic vitality strand" (24). Stern also refers to these different strands as overlapping neural networks. This is about far more, he argues, than we can indicate through the simple sense of "embodiment." The emergent aliveness of

vitality forms pertains to the most fundamental activity of the human perceptual system's production of a meaningful world from a physical environment.

Animation as a medium, or supermedium, is also built from vitality forms. Its figures emerge from them. We can see something of this in what is probably the most famous definition of animation, advanced by Norman McLaren, one of the most important and prolific experimental animators in the history of the medium: "Animation is not the art of drawings that move, but the art of movements that are drawn. What happens between each frame is much more important than what exists on each frame. Animation is therefore the art of manipulating the invisible interstices that lie between the frames" (Quoted in Wells 1998, 10). Animation is also completely dependent on the fact that our sense of aliveness is not limited to what we traditionally conceive as living beings. Since, conventionally, affects only pertain to subjects, the shift Stern makes from the term "vitality affects" to the term "vitality forms" opens up the concept to wider applications for him. For our purposes here, however, I have retained the term "vitality affects" to stress the reciprocity, or interoperativity, involved in our entanglements with media.

There's no better figure through which to observe the contemporary forms of interoperative vitality affects than Hatsune Miku, the virtual pop idol. Miku picks up where AnnLee leaves off. But her emergence onto the scene takes a very different route. In 2003, Yamaha developed the first vocaloid software, a mixable and manipulable data bank of voice samples. Vocaloid software was originally developed to allow professional music producers to create synthetic vocal tracks. In 2007, Crypton Future Media developed its own vocaloid, but unlike previous versions of the software which were not attached to a particular image, they marketed it with—or perhaps better, as—an anime-style character. They called her Hatsune Miku, recruited the

well-known illustrator Kei Garo to create an image of her, and assigned her characteristics: Miku is a 16 year old girl with 2 long turquoise pigtails. She is 5'2" and weighs 93 pounds. She is modeled as a conventional anime-style girl android, with large eyes, tiny mouth and nose, long legs and a short skirt. Miku triggered an immediate effect, and quickly became the most popular vocaloid.

It was her presence on Nico Nico Douga, Japan's most popular video sharing site, however, that exploded her popularity. According to Mark Oppenneer, "Producers, visual artists, animators, musicians, composers, and other creative types began working together on what Hamasaki calls 'massively collaborative creations,' music videos created by people who had likely never met." These massively collaborative fan productions are what enabled Miku's real birth. By just nine months after her release in 2007, over 36,000 Miku videos were

shared on the site. A YouTube search for "Hatsune Miku" in January of 2017 returns about 3,640,000 results. Many of the fan videos are stunningly compelling. Although they maintain Miku's assigned properties, her turquoise pigtails, short skirts and dresses etc., they reimagine her visually in widely varied ways and some exploit the machine synthesized capacities of her voice, emphasizing vocal feats that only an android—or gynoid, to use Mamoru Oshii's term—can perform.

Massively collaborative fan videos are not at all the only Miku productions today. There have been a wide variety of Miku video games released, from the first *Hatsune Miku: Project DIVA* in 2009 to *Hatsune Miku: Project DIVA Future Tone* in January 2017. Most of these have been conventional rhythm games in which the player tries to match Miku's dance moves (and sometimes vocal notes), but in December of 2016 SEGA introduced a new kind of entry, Hatsune Miku VR Future Live.

This entry needs some more context. One of the most interesting features of the Miku phenomenon—particularly, it seems, to the Western news media which has largely focused on this aspect—is that she fills stadiums for her concerts. Backed by a live band and in front of a live audience, Hatsune Miku sings her collaboratively-produced fan songs as a larger-than-life hologrammatic performer. (On October 8, 2014, promoting a concert appearance in NYC, she appeared on *David Letterman* in this form.) A dancing, lyric-chanting, glow stick waving crowd cheers her on, with many audience members dressed as their J-pop idol. Commentaries by North American reviewers often follow a similar trajectory, beginning with the apparent strangeness of going to see a "fake" pop star live, and then marveling at the contagious affective potency of the experience. Forrest Greenwood has remarked on the challenge on Hatsune Miku for Western audiences: She crosses an assumedly inviolable "ontological cut" between screen and spectator, image space and body space.

Hatsune Miku: VR Future Live is not exactly a game. A player who dons PlayStation's VR headset can have Miku play a concert in his living room, bringing her into his intimate space. Another Miku VR application takes this intimacy a step further. In 2013, a Nico Nico Douga engineer developed an app, to be used with the Oculus Rift VR headset, that allows the user to sleep with Hatsune Miku (Tackett 2013). When the user puts on the headset, Miku will address him as "Master" as she settles into bed beside him. She makes little sleepy noises throughout the night, and if her companion awakes she will ask him what's wrong. She can even be used as an alarm clock, sitting up and urging her Master to wake up at a programmed time.

This brings us to the rub: Unlike AnnLee, whose collaborative circuit remained within the artworld, Miku really is open source, a collaboratively produced, ongoing form of life created through the distributed, interoperative vitality e/affects of her professional creators and handlers and her multitude of fans. These fans relate with Miku in extremely various and creative ways, from the videos and games I discussed above to different types of cosplay activities. Both fans' affects and what I think we can fairly call Miku's affects are multiple. If we want to think about Miku's affects literally, we need only look to *Hatsune Miku Append* (released in 2010). This add-on package contains six different tones for Miku's voice: Soft (gentle, delicate voice), Sweet (young, chibi voice), Dark (mature, heartbroken voice), Vivid (bright, cheerful voice), Solid (loud, clear voice), and Light (innocent, heavenly voice). Just as Miku has no one creator, she herself isn't "one" but "many" —or perhaps she is both at once. Her fans are both male and female and their interactions with her certainly cannot be reduced to any single motivation or intention. But we can't overlook the configuration of gendered attributes with which Miku has been endowed, or many of the dynamics to which they give rise. And it's not just Miku, of course. Since Huyghe and Parreno could have chosen any base

character to create AnnLee, it's clearly not accidental—despite their assertion that she could just as easily have been Swedish—that she's also a young, Asian, anime-style female.

First, a note on geopolitics: As Dominic Pettman has noted, Japan, along with other East Asian countries, is often seen as the cutting edge of media culture, the place where our futurity is currently being engineered (Pettman 2013). It's easy to discern the operation of a widespread techno-Orientalism (that is, the exoticization or othering of Asians produced through associating the broad category of Asian-ness with extreme forms of technology), and thus to dismiss claims of a geopolitically-determined techno avant-garde. But particularly where medial lives and their interoperative vitality affects are involved, Japan does seem to be at the forefront of production. While as early as 1931, Walter Benjamin would think Mickey Mouse as both the emblem of the modern "image sphere" and the best instructor as to how to live in it, today, the animatic character (referring to both still and moving images) probably finds its most vital, interesting, and ubiquitous forms in Japan and South Korea. Hatsune Miku of course brings with her longstanding traditions of gendered representation in Japanese culture as these have been taken up in manga and anime: She's not only female, but a teenaged female, slender, long-legged, short skirted and, like many anime characters, has a hybrid of Asian and Caucasian features and an android-like aspect.

One US reviewer has remarked that each of the nine costumes of her hologram in a concert in 2016 seemed just about to offer a view up her skirt. Of course, this effect doesn't emerge only from the design of the costumes. It's rather the way Miku's movement and costume are rendered together (Machkovech 2016). Although a search for gender-bender Miku turns up a number of results, these are less frequent than one might expect. Miku tends to maintain the qualities assigned to her at birth across diverse incarnations. We see these amplified in the Sleep Together app,

but female Miku cosplayers tend also to remain within the spirit, if not the letter, of these laws. While contemporary conventions of gender representation—and production—are of course somewhat different in Western countries than they are in Japan, the phenomena Miku draws our attention to so powerfully, both in relation to the creative potentials of media culture and its production of hyper-gendered forms, are just as potent here.

Living Images 2: The Animation of Jazz

I want to turn now to a very different site, the media representation of transfeminine girlhood. One of the places we've been seeing the most intensive depiction and discussion of gender in relation to animatic plasticity is in the recent explosion of popular media focused on transgender folks. The years 2014–2016 saw the appearance, for example, of a wide variety of TV shows devoted to transgender characters ranging Jill Soloway's wonderful Amazon comedy series, *Transparent*, to the reality series *I Am Cait*, *I Am Jazz*, *Becoming Us*, and *Strut*, Whoopi Goldberg's transgender *riposte* to *America's Next Top Model*, to name just a few. These bring up some fascinating—and, of course, fraught—issues in relation to the bodies of the animatic apparatus.

While there have always been people who have "passed" and lived out their lives as members of the sex not assigned to them at birth, the mainstream media tends not to focus on this aspect of trans experience—that is, the lives that trans men or women establish once their public identities have become settled. Nor does it generally focus on the trauma of sex-gender discordance. It's the transition in trans: the coming out, the effects of hormone therapy, the contemplation and, sometimes, the process of surgery, the shifts that take place in relationships when the trans woman (it's usually a woman) or man assumes an identity that may feel primordial to him or her or them, but that's new to their friends and loved ones. A YouTube search for "transgender" returns about 1,370,000 hits, and a survey of videos posted by

trans people on YouTube (obviously a self-selecting group) also reveals an insistent focus on the process of transition and the plasticity of corporeal morphology.

The *narrative* of transition that the subjects themselves emphasize, however, even amidst detailed and sometimes graphic testimonies about experiences with hormones and surgeries, traces their desire to manifest who they really are, that is, to develop a physical identity that matches the psychic one they have always inhabited.[3] In the standard trans plot that appears in mainstream media, the protagonists explain how they're finally able to manifest their true identity as a "woman" or "man."

What we often find then is two different kinds of narrative lines moving in different directions, and operating in different modes, in the same story. One moves from a conception of the primordiality of gender to its correct, physical manifestation as telos, while the other tarries with—and sometimes sensationalizes—process, metamorphosis, and gesture. In one sense these texts thus remain in the transitive space of transition, and in the genderqueerness of this space. In another, they emphasize conventional forms of femininity or masculinity as both the motivation and the goal of transition. We can see both of these as responses to the novel potentials for corporeal transformation in the animatic apparatus, and particularly to the metamorphic possibilities opened up by biomedicine and technology. One rejects the destabilizing consequences of this in relation to gender and the other embraces it or, at least, is fascinated by it. At the heart of both the reactionary cultural responses that see gender transition and even gender nonconformity as "against nature" and the contemporary cultural fascination with transition itself lies the an-ontological pressure of trans bodies vis-a-vis, their perceived disturbance of the categories of gender bimorphism.

As Susan Stryker details, when a baby is born the first

declaration is typically "It's a girl!" or "It's a boy (Stryker 1994). It is as if a sex-gender determination is necessary in order to admit the newborn into the world of living human beings. It is precisely because gender is such a fundamental cultural category, then, that transgressing its ontological boundaries is regarded as a serious matter, conjuring utopian possibilities to some and dystopian ones to others. Preciado makes this point emphatically: "We could compare our gender regime to a highly orthodox theological one in which the idea of God can't be questioned. In our contemporary, high-tech society, questioning the binary gender norm is our heresy. Genderqueer bodies are the new heretics" (Preciado 2013, np).

Where genderqueerness is a kind of heresy, it's perhaps not surprising that the becoming-visible of transgender subjects, as it operates in mainstream popular culture, would focus on becoming-visible as also a process of becoming- "male" or "female." According to J. Jack Halberstam, writing about art that figures ambiguous embodiments, "the transgender body is not reducible to the transsexual body, and it retains the marks of its own ambiguity." The works he discusses (by Del LaGrace Volcano, Jenny Saville, and others) are confrontational in that they resist gender as binary; they embrace their particular differences and the powers of difference itself. He also suggests, however, that "while the transgender body has been theorized as an in-between body, and as the place of the medical and scientific construction of gender, when it comes time to picture the transgender body in the flesh [outside of subcultural and art practices], it nearly always emerges as a transsexual body" (Halberstam 2005, 79). The forces of becoming visible in mainstream media culture tend toward turning genderqueerness into conventional, legible masculinity or femininity.

I want to turn to focus on one text, the TLC reality TV series, *I Am Jazz* (2015–2016). What interests me about this work (which follows the common script I began to describe above) is the

manner in which it so starkly reveals the ways in which animatic bodies confront forces of normativization. As I described in the previous chapter, moving image animation is always produced in an encounter between animation's an-ontology, its plasticity and metamorphics, with cultural traditions of representation, and through this encounter are produced not only figures but a commentary on figuration. In other words, because in a hypothetical dimension everything is possible in animation, animation always also tells a story about constraints, about the pressures exerted both by materials and by representational conventions.

I Am Jazz tells the story of the animation of Jazz as a figure: It follows transgender teen Jazz Jennings as she finishes middle school (season 1) and enters high school (season 2). But she was in the public eye long before the start of her series. At 4, she was the youngest person ever to be diagnosed with what was then called Gender Identity Disorder (now, post DSM-V, it's Gender Dysphoria), and when she was 6 she was interviewed by Barbara Walters in her special on transgender children, *My Secret Self: A Story of Transgender Children* (April 27, 2007, ABC News). Jazz has co-authored a children's book on being transgender, *I Am Jazz*, and, more recently, a book on her life as a transgender teen, *Being Jazz*. She was also, in 2016, the youngest ever grand marshal of the Pride Parade in NYC.

Jazz—as a media personality—is undoubtedly a singular phenomenon. She's not only grown up in the public eye, but grown up as a kind of emblematic figure for the trans community, or at least for trans representations in mainstream culture. But her series showcases much broader issues provoked by the affordances of biomedicine and the kinds of bodily plasticity they make possible. It highlights the interplay between the transgressiveness of trans in relation not only to gender identity but to all traditional concepts of the body's biological or theological destiny, at the same time as it spotlights the forces

of normativization that are brought to bear on bodies/subjects that threaten the coherence of society's fundamental ontological categories.

What interests and concerns me about Jazz's narrative in particular is the way that her status as an adolescent, that is, as someone who is already in the transition of growing up, interacts with the story of her gender transition. From one perspective, Jazz and her family are gender radicals. After all, coming out and into the public eye as trans can't be an easy thing to do. She and her family are subjected to the vitriol of the many, many people who regard their common project as against god, or against nature—who regard them as "heretics," to use Preciado's term. But despite her emblematic status as a trans child, the series attempts to make her "relatable" through the activation of a normative femininity. In the interests of rendering her a regular girl who likes pink and sparkles, mermaids and boys, it actively prevents her from being queer and not only in the sense of her gender, but in the sense that adolescence is also queer. The phrase "normal girl" occurs with surprising frequency, and the series doesn't want to admit moods or desires that disrupt its central narrative—even though these at times break through. For me, they are the show's most interesting moments.

When we meet Jazz at the beginning of season 1, she appears as the "normal girl" she and her mother insist she is. The show introduces Jazz through video footage and photos of her as a child. From the time she was 2, she wanted to wear girls' clothes and play with girls' toys. We see her wearing plastic, feathered girl's dress-up shoes. All of her preferences are for "girly" things. At a dance recital when she is 4, she stands angrily still in shorts and a T-shirt as the girls—all of the other children are girls—dance and twirl in their tutus. For Jazz's mother, Jeanette, this is a kind of tipping point and precipitates the visit to the doctor in which Jazz receives her diagnosis. We see her happy at her 5th birthday party, wearing a shiny rainbow-colored girl's

swimsuit. Her social transition—her freedom to be a girl to friends, family, and schoolmates—make her a happy child. But the approach of puberty triggers a crisis—or, at least, a dilemma. If her development is left to progress without interference, she'll develop male secondary sex characteristics. Her parents decide to use puberty blockers to give Jazz's gender identity some breathing room. But it doesn't last long. By the time we meet her at 14, she has already been taking estrogen for two years to initiate female puberty and breast development. As the series presents it, everything is going well. Jazz looks like a normal girl (in the show's own rhetoric here), and in middle school we see her with a close group of girlfriends that shop, gossip, and obsess about the size of their breasts.

But season 1 consistently notes that the following year will bring the transition to high school and all that that entails. It focuses on what might happen when her peers begin to date and "pair off." Although Jazz does make a trans girlfriend toward the end of the season—and will go to a support group for trans teens in an episode of season 2—the show is predominantly focused on Jazz fitting into the cisgender milieu of a typical South Florida high school. Despite her own assertions on the show that she doesn't yet know her sexual preference (not to mention her YouTube declaration that she's pansexual), the series only entertains the scenario that she will date a cis boy.

Somatic Individuality: Plasticity and Normativity

While the eponymous Jazz is the center of the series, its narrative also focuses on her family: her mother, Jeanette, her father, Greg, and her older siblings—a sister, Ari, and twin brothers, Griffen and Sander. As the series intro declares, the Jennings are an ordinary family presented with extraordinary circumstances in the form of Jazz's gender nonconformity. (Jazz's mother is clearly the orchestrator of Jazz's itinerary as a media personality and activist for transgender rights. She's taken this on as her own

project.) The show interviews family members often, including her maternal grandparents, and it showcases family relationship issues and stages media-worthy family events.

There's one feature of this normality that I want to focus on in particular: The show clearly takes place on the terrain of what Nikolas Rose calls "somatic individuality":

Selfhood has become intrinsically somatic—ethical practices increasingly take the body as a key site for work on the self. From official discourses of health promotion through narratives of the experience of disease and suffering in the mass media, to popular discourses on dieting and exercise, we see an increasing stress on personal reconstruction through acting on the body in the name of a fitness that is simultaneously corporeal and psychological. Exercise, diet, vitamins, tattoos, body piercing, drugs, cosmetic surgery, gender reassignment, organ transplantation—for "experimental individuals" the corporeal existence and vitality of the self have become the privileged site of experiments with subjectivity (Rose 2001, 18).

There is thus a clear cultural injunction that everyone participate in a body project which involves working on the body as a means of expressing and improving one's self, a self that is conceived as preexisting its corporeal expression.

I Am Jazz is throughout devoted to somatic individuality as an ethos. The whole family, for example, takes on a fitness challenge that involves group workouts and weigh-ins and various attempts to eat more healthfully, and that culminates in the family's joint participation in an obstacle course challenge. In another episode, Jeanette takes each of her sons on a special mother-son outing in response to their complaints that she's too exclusively focused on Jazz. Sander, who's troubled by the aftereffects of a knee injury and subsequent surgery—as well as

by what he sees as Jeanette's lack of concern for his well-being—she takes for a session with a physical therapist who works with famous athletes. Griffen, the mellow one, she takes on a date to a nail salon where they both relax and he finds a cure for his gnarly toenails.

Jazz herself—her transition and even her identity—is explicitly described in medical terms. Jazz receives a diagnosis and undertakes a course of treatment, and this structures the series' narrative in many ways. Doctor's appointments are featured extremely prominently. They're set up through multiple interviews and staged conversations that work to render them as suspenseful events. Is Jazz's testosterone blocker functioning properly? What will happen if it isn't? How are her estrogen levels? Should she increase them to accelerate female puberty but possibly stunt her growth in height? Two of the show's most telling moments occur in this medical context.

In one sequence, Jazz and Jeanette go together to an appointment with a plastic surgeon. Jeanette has won free Botox injections and she decides (after overcoming objections from Jazz's father) to take Jazz along for a breast surgery consultation. Jazz's consultation is first. The doctor examines Jazz and diagnoses her with "tuberous breast deformity" which, he says, will not resolve on its own as she continues to develop. He recommends surgery but says that he and most surgeons follow WPATH (World Professional Association for Transgender Health) recommendations and only perform the surgery when the patient reaches the legal age of consent, eighteen. Jazz says she won't be satisfied with herself until she likes what she sees in the mirror, but doesn't object to the wait. It's Jeanette's turn next. The doctor says she doesn't need Botox and suggests a "Restylane lift." We move to the treatment room and watch the doctor insert needles into Jeanette's skin to inject the product, and then wipe away the blood. Jazz, standing by her mother's side, watches too—and then gets woozy after the treatment is

finished. "Beauty is pain," Jazz says in an interview following the sequence.

This is a crucial scene as it so explicitly places Jeanette and Jazz's corporeal alterations in the same context. It wants, I think, to enact a kind of reciprocal normalization by aligning the procedures. Jazz's desire for "porn star breasts" and breasts like she "sees on TV" is equated with her mother's desire to appear younger. The reason this is especially interesting is that it disrupts, or at least complicates, the show's explicit narrative which very carefully, and frequently, positions Jazz's transition in relation to a quite different kind of medical logic, one that stresses the life and death stakes of gender dysphoria and the necessity for transition as a lifesaving treatment. It also tends to portray transition teleologically rather than as an ongoing process, where this scene appears to place Jazz's transition both as engaging a traditional female quest for beauty and in relation to a body project depicted, via Jeanette, as potentially open-ended. These logics aren't necessarily mutually exclusive, but the way in which they're conjoined on *I Am Jazz* reveals the show's investment in a kind of strange and incoherent multifront siege of normativity.

I Am Jazz positions certain aspects of animatic an-ontology and its metamorphic body as frictionlessly compatible with, and even inseparable from, the aspirations of this normal family. Somatic individuality is good. Falling outside of clear, visual categories of femininity and masculinity is not. Toward the end of the first season, Jazz makes friends with another transgirl, Noelle. Together, they burn Noelle's male clothes. The title of this episode, "I Looked Like a Man in a Dress," is a quotation of Noelle's declaration to Jazz, and here, as well as in subsequent episodes in season 2, Noelle is compared unfavorably to Jazz. Noelle is just starting to transition, at 14, and the show argues that this makes it more difficult, awkward, and dangerous for her than it's been for Jazz because she's gone through male

puberty. She also provides a visual foil for Jazz's superior femininity, and a narrative foil for stressing the wisdom and benefits of transitioning early. While this narrative is supported by Noelle's revelation that she was only allowed to transition (that is, start hormone therapy) following a suicide attempt, the visual dimension of the comparison stresses a clearly gendered appearance and role as the goal for any transgender person.

But this narrative has its disruptions, and one in particular crystallizes both what the series wants to do—and what it needs to contain in order to do it. The episode focuses on Jazz's surgery to have her expired testosterone blocker removed and replaced with a new one. For a variety of reasons, including issues with insurance not agreeing to pay for the procedure, Jazz and her family travel from their home in South Florida to Los Angeles, where Jazz has the procedure at the LA Children's Hospital. The show is extremely invested in displaying the procedure as fully as possible (as it does with Jeanette's "lift"), and follows Jazz first into the operating room and then into the recovery room. (I'm not sure why Jazz is placed under general anesthesia as the procedure itself is usually done in a doctor's office and appears relatively minor.) The doctor cuts the skin to remove the existing subcutaneous implant and to replace it with a new one. In this case, it becomes a bit more dramatic as the old blocker has broken and the surgeon has to fish around a bit to find the broken piece. We follow the family into the recovery room, and watch Jazz wake up from the anesthesia. She's predictably loopy and says, "I have a boner." Given the show's disavowal of Jazz's sexuality and her relation to any male features (outside of some rare and euphemistic references to her "area") this is an unusual moment. It's clearly unscripted and what's interesting is this flash opening for a kind of queerness to emerge. And one related at least as much to adolescence as to gender and sexuality per se.

Before I discuss this, I want to return to our discussion of body projects. Many of these—from pharmaceuticals to yoga to

tattooing—involve the cultivation of various forms of sensation, of a body that feels and responds in particular ways. Other body projects, however, are much more explicitly bound up with producing the body *as* an image. Now, appearing in a particular way can produce cascades of affect and feeling, particularly in our own culture in which many of our interactions with others take place online rather than in the location of the "physical" body itself. But with body-image projects, from Instagram posts to plastic surgeries, the sensing body—the emergent layer—is very much secondary to the image-body.

The series stages Jazz's psyche. The opening of season 2, for example, relates that Jazz is just emerging from a difficult period of depression and makes reference to the effects of hormones on her moods and her prescription for antidepressants. It also stages her body as a body that *appears*, both in its narrative and in the way the camera relates to Jazz. What it consistently occludes is a body that feels and experiences the world.

Jazz's loopy moment in the hospital points to this conspicuous (and, I think, quite intentional) absence in the production of the series' narrative. Jazz directly follows her assertion with a question directed to her mother. "Is that okay?" Jeanette smiles, laughs nervously, and says, "We're filming." Of course, reality shows in general are highly staged productions, and *Jazz* may be even more tightly constructed than others because it's very clearly intended as a kind of PSA for and about transgender youth, with Jazz herself as role model and activist. But this makes even more notable its repression of queerness as what falls outside of or in between gender categories. It's interesting to me that they even included this scene. Its delightfulness— Jazz's spontaneity, Jeanette's embarrassment—must have been too hard to resist. In this instance, the drama of the spectacle was more important than staying on message.

And in this moment, Jazz as a teenager flashes into our view: She is someone for whom puberty and its changes are

not only a medical and social issue to be managed but also a time of surprising and evolving sensations. Adolescence is itself a transition and, in contemporary culture, a time and space in between childhood and adulthood which is often valued for its pluripotentiality and the space it opens for experimentation. It is also a period in which a great proportion our new experiences of vitality affects issue from the changes in our own bodies and the new kinds of desires they provoke. I am not intending at all to reify the body, or its forces. Both, as I've emphasized, emerge from psycho-physical-object-image-narrative circuits that are always morphing and transforming. But the developmental pressures of biology on our psycho-physical becoming are especially profound during adolescence. Our body schemas, to use Schilder's term, change more rapidly with the changes in our physical bodies. Our worlds likewise morph constantly.

Jazz is beautiful, and it is her charisma that makes the series watchable, but she seems trapped in the space of the show and its presentational logic. A certain kind of potentiality and experimentation feel foreclosed. This is because of the way that the affordances of the animatic apparatus in relation to the expressive potentials of gender difference and variation are constrained by their channeling into normative molds. It is also because her adolescence is highly managed—and planned in advance. While one can easily make the argument that this in fact always the case, and that it's not *that* it's planned but *how* it's planned that distinguishes Jazz's experience, this *how* is extremely consequential.

Conclusion

How-Ethics

I've argued throughout this book that in the animatic apparatus body and image interpenetrate in remarkable ways. My objective in the previous chapter was to bring home the enormous impact this has had on our contemporary life worlds. Jazz Jennings' coming out is as much about its media staging and consumption as it is about the more intimate practices of taking hormones or shopping for clothes. Hatsune Miku's status as a virtual being seems only to enhance her appeal—and her affective and libidinal force—to the fans who use the *Sleep Together App*. It is as impossible to establish boundaries here between intimate spaces and media spaces as it is to establish where images end and bodies begin, where truth or the real might reside, or on what side of this vestigial division between spectator and screen we find "life."

The crucial question with which I've had to contend in thinking the animatic apparatus is how to think an ethics that could function in a space in which traditional conceptions of reality, ground, and limit have dissolved. That is, if ethics has been thought in terms of finitude, the particular ontology of human being, and being toward death, and if the animatic apparatus dissolves these fundamental limiting, ontological denominations, where does this scenario open onto its own immanent critique, its own positive possibility? There seem to me to be two possible directions here, back toward ontology, limit, and the real—or further into the virtualization of life. In the space opened by the latter, there can still be ethical thought but, as I've suggested, it would have to be configured not around ontological commitments and their questions of who? and what? but rather around the embrace of the one an-ontological

determinant: how?

Post-Truth: Media in the Age of Trump

We seem now to be living in a more dystopian moment than I could have imagined as I began to write this book. It is my continued hope and aspiration that the events I discuss below will not come to define the politics of the contemporary moment for history. It's difficult to avoid seeing, however, the manner in which manifestations of the animatic apparatus have taken a dark turn. It has been exactly one week since Donald Trump was sworn in as the 45th President of the United States, and this week has been a startlingly busy one: We've seen the reinstatement of the "global gag rule," a policy that denies funding to international organizations that include abortion in discussions about women's health and family planning. (Funding has always been denied to abortion providers, but this policy has a much broader and more deleterious reach.) Trump has set the wheels in motion to build the fortified wall at the border between Mexico and the US that he promised during his campaign. He has declared that the federal government will deny funding to "sanctuary cities," that is, jurisdictions in which law enforcement does not facilitate the federal government's (anti-) immigration protocols, such as indefinitely detaining people suspected of not being in the US legally.

Much of the media discourse around Trump's presidency this week, as jam-packed as it's been with executive orders and memoranda that will have a profound effect on US policies and on the lives of millions of people globally, has focused on the "truth" of two of Trump's claims. One claim is that millions of undocumented immigrants cast ballots illegally, and that Hillary Clinton's 3 million popular vote lead is the result of voting fraud. Dan Barry in the *NY Times* had this to say about the evidentiary basis of this assertion: "As far as anyone knows, the president's assertion is akin to saying that millions of unicorns also voted

illegally" (Barry 2017, np).

The second claim that generated a news cycle, or spiral, and that focused on truth as a problematic involved Trump's continuing assertions that his inauguration hosted the largest inauguration day crowd in US history. This issue also involved the evidentiary status of images. By Monday, all of the major news outlets—and many smaller ones—were running articles that contrasted photographs of Obama's inauguration in 2009, where the crowd was estimated at 1.8 million, with images of the audience at Trump's inauguration, which most "crowd scientists" estimate at around 600,000. All manner of data analysis was run on these images as well as on CCTV footage and DC Metro ridership numbers to determine the headcount as accurately as possible. But the crucial issue that comes to light here is that the disparity between the images is so great that if anyone believed in their truth, that is, in their status as veridical representations of the real, then all of these articles and all of this data and all of the subsequent analysis would be unnecessary. And in the face of all of the data, some people believe one set of facts, and others believe what Trump advisor Kellyanne Conway called this week "alternative facts." While many journalists and others rightly urge "calling a lie a lie" rather than hedging about truth or its absence (Barry 2017), the proliferation of these images and their related analytics only confirm the animatic apparatus's untethering of representation and reality.

The Oxford Dictionaries word of the year for 2016 is "post-truth." Oxford defines this as "relating to or denoting circumstances in which objective facts are less influential in shaping public opinion than appeals to emotion and personal belief." Their primary example of its use in a sentence is "*'in this era of post-truth politics, it's easy to cherry-pick data and come to whatever conclusion you desire.'*"[1] This is another way of describing the status of the political in the animatic apparatus, as well as pointing toward questions of response and responsibility in this

situation. While post-truth thus refers to a scenario whose scope exceeds the phenomenon of Trump's Twitter politics, let's open the Trump effect to help us to understand it in relation to the animatic apparatus.

Trump's appeals to emotion capitalize on the contagious affectivity of the animatic media sphere. His apparent lack of concern for being proven wrong emerges, and allows him to profit, from the way that the sheer amount of "information" and the speed of its transmission and turnover have led to the production of affective-ideological echo chambers in which political consumers only consume news and ideas that conform to and amplify their already determined feelings and beliefs. Another candidate for Oxford's word of the year was "filter bubble." This expression describes how search term algorithms produce these echo chambers by anticipating what someone is looking for based on their location, demographics, click behavior, and search history and thus, in effect, produce a future by predicting it. But it's also used more expansively to portray how the current media-political landscape leads to the production of sealed-off, self-replicating worlds. (The filter bubble phenomenon is equal opportunity; filter bubbles may develop in relation to any individual or collective identity.) Trump's victory is a symptom of a particular response to the an-ontological dimension of the contemporary world that we've encountered before: the impulse to do anything to restore a ground, to establish borders, to build walls, to deny others and otherness entrance to an enclosed, fortified space. In other words, the impulse to produce a strong, nationalist, identitarian politics.

How-Ethics 1: Agamben's Gesture

Giorgio Agamben points us toward a manner of thinking about the question "how?" in its relation both to ethics and to the "positive possibility" of what he calls, following Guy Debord,

the society of the spectacle. This is one part of his larger project to imagine a non-statist, non-teleological, non-identitarian politics. How might we conceive, he asks, a community without a basis in the identity of its members, a belonging without an ontological foundation or reference, an an-ontological community, politics, and ethics?

I'll juxtapose two passages from neighboring essays from *The Coming Community*. The opening of "Ethics" reads:

> The fact that must constitute the point of departure for any discourse on ethics is that there is no essence, no historical or spiritual vocation, no biological destiny that humans must realize. This is the only reason why something like an ethics can exist, because it is clear that if humans were or had to be this or that substance, this or that destiny, no ethical experience would be possible—there would only be tasks to be done (Agamben 1993, 43).

The end of the essay that follows it, "Dim Stockings," concludes:

> To appropriate the historic transformations of human nature that capitalism wants to limit to the spectacle, to link together image and body in a space where they can no longer be separated, and thus to forge the whatever body whose physis is resemblance—this is the good that humans must now learn to wrest from commodities in their decline. Advertising and pornography, which escort the commodity to the grave like hired mourners, are the unknowing midwives of this new body of humanity (50).

In the first passage above, Agamben asserts that ethics is made possible, is opened, by humans' lack of any essence or destiny. If humans had an essence or destiny, he explains, it would only be a matter of figuring out what tasks need to be done in order to

accomplish it, and there would be no need for ethical questioning or, as Agamben has it, ethical experience, at all. The flip side of this formulation is also true for Agamben: Where humans perceive their experience in terms of a particular biological destiny or spiritual vocation, the sphere of ethics is occluded.

Agamben conceives his definition of ethics, as I've suggested, in relation to the "positive possibility" of the society of the spectacle. The spectacle, Agamben writes, "disarticulates and empties, all over the planet, traditions and beliefs, ideologies and religions, identities and communities" (Agamben 2000, 85). That is, it has accomplished the destruction of traditional notions of biological destiny, spiritual vocation, cultural identity, individual biography, theological destiny, etc. The positive possibility of the society of the spectacle lies in the manner in which its very destructions may reveal the domain of ethics—as the default of any particular destiny or identity for human being and the corollary openness of its potentiality.

According to Agamben, the "massive manipulations" of the body—and especially the female body—in the spectacle likewise tear human notions of the body from their traditional relation to both theological and biological essences. Agamben also asserts, and here incorrectly—or rather, in a manner inconsistent with more contemporary developments—that capital's desire is to have all transformation take place on the side of the spectacle so that the body, as in *La Dolce Vita*, continues to survive, but only in its shadow. He writes, "what was technologized was not the body, but its image. Thus the glorious body of advertising had become the mask behind which the fragile, slight human body continues its precarious existence, the geometrical splendor of the 'girls' covers over the long lines of the naked, anonymous bodies led to their death in the *Lagers* (camps)" (Agamben 1993, 49).

Agamben is referring to the Tiller Girls, a dance troupe that performed in theaters and cabarets in Weimar Germany and was

described by Kracauer in his famous essay of 1927, "The Mass Ornament." But one can also imagine the conceptually identical, if cinematically realized, rows of women in Busby Berkeley's musical numbers, arms and legs swinging in perfect tandem to produce formal geometries, individual bodies submerged in his mechanically timed, perfectly optimized optical girl-machine. Agamben suggests that these spectacular, technologized image-bodies screen the violence enacted on the real bodies effected by machinic processes of killing in concentration camps. According to Agamben's example, all of these sites are possessed by the same logic of bodies whose movements are timed to the rhythm of the machine (whether factory conveyor belt or forced march), where the "girls" produce a spectacular, "ornamental" version, making it available for consumption and enjoyment. To this example, with its very particular topography and logic, Agamben adds several others—including the transsexual body—with extremely different configurations, ones in which the body is clearly directly materially invested and transformed. He doesn't, however, note the shift in topography—or in apparatus.

The crucial point for us here, however, is that in the conclusion to "Dim Stockings" quoted above, Agamben in fact calls for the very scenario that we've already seen realized in the space of the animatic apparatus: that is, "to link together image and body in a space where they can no longer be separated" (Agamben 2000, 50). From the fantastic dimension of the animatic body as presented in the Esurance ad campaign to its more material versions in the plastic surgeries of Heidi Montag or the multi-modal transformations of the Human Barbie, and from the new biotechnological processes Franklin and Lock describe to the cinematic-animatic compositings that produce the digital bodies of *The Lord of the Rings*, *Avatar*, etc., the hallmark of these animatic bodies is that they "link together image and body in a space where they can no longer be separated."

In the passage quoted from "Dim Stockings" Agamben also

refers to the body he summons as "a whatever body," and he explains it—in reference to both the *quodlibet* of Scholastic philosophy and the photographic lens—as "being such that it always matters." The whatever body is a kind of singularity inseparable from all of its own predicates, but unrelated to any model—except by a "resemblance without archetype" (48). It no longer maintains a reference to a theological origin or to any model, except through the "Idea" of resemblance, a resemblance without actual substance. The "whatever body," with all of its determinate indeterminacy, remains static in its insistence on the maintenance of the logic of resemblance—as well as in its insistence on the absolute qualification of being. It's hard to imagine that "the new body of humanity," given the field of forces of the animatic apparatus, could be so definitely in possession of its attributes.

It seems more apt to imagine them as "however bodies," that is, in terms of their modes of production and transformation and the forms and modes of life and experience these emergent and continually emerging bodies produce. And, finally, whether they are, as Oshii would have it—sounding quite a bit like the Spinozist Deleuze or the Guattari of *Chaosmosis*—"good for" other bodies. What I want to retain from Agamben's formulations here is the manner in which we may articulate the particular conception of ethics he develops as the default of essence, vocation, and telos—and its corollary potentiality—with the contemporary phase of what Agamben calls (after Debord, of course) the society of the spectacle and what I'm calling the animatic apparatus. If it is the case that ethics—like the however bodies of the animatic apparatus—don't refer to a biological or theological ground or telos, then that opens a space to consider their forms of production and metamorphosis along new lines, that is, in relation to the how? of their unfolding. Agamben's conception of gesture offers a useful starting point for the development of how-ethics.

Gesture, for Agamben, is what takes place when all definitive locations—life and art, text and execution, reality and virtuality, power and act, personal biography and impersonal event—are suspended. In this opening, what appears—or plays—is gesture. According to Agamben, gesture is a special kind of action, neither a means nor an end. He distinguishes it from Aristotle's conceptions of a making that would produce something (from or by means of itself), and an action that would enact something (existing before it). Gesture pertains to a third kind of action that Agamben, following Varro, characterizes as carrying, enduring, supporting. It is "pure praxis" freed from any preexisting determination (such as life or art) and freed of any telos, including any aesthetic one (such as art for art's sake).[2] The realm of ethics, for Agamben, is the sphere of gesture: that is, it is that realm in which the third kind of action—as means without end—unfolds.

Agamben has a kind of formula for gesture that unifies its otherwise diverse sites of appearance: "The gesture," he writes, "is the exhibition of a mediality, it is the process of making a means visible as such" (Agamben 2000, 58). This formula holds, to cite Agamben's own examples, for both the porn star whose gaze at the camera reveals that her exhibition takes precedence over her engagement with her partner, and for the mime who, estranging gestures from their normal ends, exhibits them in their pure mediality—that is, shows them in their pure being-in-a-medium. The issue becomes here, then, what does this revelation of mediality make possible? What kinds of ethical action can emerge from its an-ontological space?[3]

Ethical Know-How

I want to turn, finally, to the suggestions Francisco Varela offers in *Ethical Know-How: Action, Wisdom, and Cognition*. Varela's work moves us into new territory. This makes it both potentially generative, even necessary, but also difficult to approach. Varela,

who died in 2001, was a fascinating and unusual thinker. A biologist and cognitive scientist, he's best known for developing the concept of autopoiesis with his mentor and colleague, Humberto Maturana, and for his work on embodied cognition. In *Ethical Know-How*, he brings together cognitive science and what he calls "Eastern wisdom traditions," particularly Buddhism, to advance a new paradigm.[4] While his direct intention was not to relate the ethical discourse he was developing to the media sphere and its operations, that is, to what I'm conceiving as the animatic apparatus, its relevance to this domain becomes very clear in the examples he uses to describe his approach to ethics, cognition, and action.

How-ethics emerges from virtuality. It demands, Varela argues, that we acknowledge our "selves" as virtual, as always coming into and passing out of "being" via our "structural couplings" with the environment. Varela distinguishes between what he calls "know-what" and "know-how" (Varela 1992). The former approach to ethics is based on the conception that ethical behavior emerges from conscious, deliberative, decision-making processes. In contrast, Varela asserts that most ethical action emerges from ethical know-how as immediate, spontaneous, and in fact independent of the deliberations of a conscious self.

This claim issues from his concept of embodied cognition— the notion that cognition arises through a subject's sensorimotor actions in the world, and is thus dictated by its form of embodiment and the kinds of sensations it affords. In Varela's sense, then, cognition is not identical to consciousness and does not require it. Consciousness is a kind of epiphenomenon of numerous distributed processes emerging from sensorimotor interactions with an environment. What's crucial for us to understand from Varela's formulation here is that environment, for Varela, is not the same as world. We live in both, but in different ways:

On the one hand, a body interacts with its environment in

a straightforward way. These interactions are of the nature of macrophysical performance—sensory transductions, mechanical performance, and so on—nothing surprising about them. However, this coupling is possible only if the encounters are embraced *from the perspective* of the system itself. This embrace requires the elaboration of a *surplus signification* based on this perspective; it is the origin of the cognitive agent's world (55–6).

This surplus signification is the threshold between sensation, as physical interactions between organism and environment, and sense as world-making, or, to use different terms, as embodying these sensory and mechanical performances in an image schema. The organism's environment may be given, but its world emerges through the manner in which it signifies this environment to itself based on the potentials and constraints offered by the specificities of its particular nervous system and its interactions. Varela describes this process with the term, enaction. Alberto Toscano offers a helpful definition of enaction as "the process whereby a world is brought forth by the interaction or structural coupling between an embodied agent and its medium or environment" and "also the study of the manner in which a subject of perception creatively matches its actions to the requirements of its situation." I will return to elaborate on these concepts shortly. But I want first to turn to Varela's deployment of them in his discussion of the animatic modes of contemporary culture to establish their special relevance here.

The two examples Varela invokes are robotics and VR (virtual reality). His discussion of robotics turns on what he describes as a contemporary consensus that traditional top-down approaches to artificial intelligence have failed to produce their desired effects. Imagining the human brain as a kind of sophisticated computer, and basing the development of AI on symbol-processing, as the dominant computationalist tradition

has proposed, has not enabled the production of intelligent agents because it misunderstands learning and creativity, tethering them to a symbolic, abstract domain that misses their emergence out of embodied, lower-level processes. He discusses the work and perspectives of Rodney Brooks, former director of MIT's Computer Science and Artificial Intelligence Laboratory. Brooks' new approach to AI developed from an actionist model related to Varela's "enaction." In order to complete even basic tasks in the human environment, he argued, a robot's higher cognitive activities would be based on sensorimotor couplings with the environment, with the addition of a proprioceptive capacity. Brooks designed robots that are used in surgical procedures as well as the robots that were used to search for survivors at Ground Zero. He calls his approach to building robots as embodied, situated agents, "the artificial life route to artificial intelligence." In this scenario, even functional robots emerge from interoperative vitality effects.[5]

All animals have worlds dependent on their perceptual apparatuses, as ethologist Jakob von Uexküll has also argued, and if the artificial life route leads to artificial intelligence, robots may develop worlds as well. Because worlds are perceiver-dependent, that is, because they emerge from the "surplus signification" generated in the interactions between specific types of particular perceptual apparatuses and the environments in which they function, we may live in the same environment as robots and animals, but we don't share the same worlds. According to Kleist and Oshii, dolls and puppets have their own worlds as well, and this is a good thing. This doesn't entail that their worlds are "poorer," as Martin Heidegger would have it of animals, but only that they are different. Precisely because the human nervous system is so skilled in creating worlds through couplings with the most various sorts of materials, interactions with others of all kinds produce new worlds of all kinds.

In 1992, Varela turns to then-new work in VR as an example:

A dramatic and recent example of this surplus signification and the dazzling performance of the brain as a generator of neural "narratives" is provided by the technology of the so-called virtual realities. A helmet fitted with cameras over the eyes and a glove or suit with electrical transducers for motions are linked, not through the usual coupling with the environment, but through a computer. Thus each movement of the hand or body corresponds to principles entirely under the control of the programmer. For example, each time my hand, which appears as a "virtual" iconic hand in my image, points to a place, the image that follows simulates flying to the place pointed at. Visual perceptions and motions give rise to regularities that are proper to this new manner of perceptuo-motor coupling. What is most significant for me here is how quickly this "virtual" world comes to seem real: we *inhabit* a body within this new world after about fifteen minutes or so... The nervous system is such a gifted synthesizer of regularities that any basic material suffices as an environment to bring forth a compelling world (58).

Varela's narrative highlights just how easily new worlds emerge through contacts with new environments, and that the ontological status of these environments (as "real" or "virtual") doesn't determine our ability to "inhabit" them. We encounter new environments and can quickly accommodate ourselves to their coordinates, not through conscious deliberations but through our sensorimotor couplings and, then, through our capacity to signify and narrativize them.

With each new world a new self also emerges; this self is thus not inherent or abiding, but what Varela calls a kind of "virtual interface," "a nonsubstantial self that acts as if it were present" (61), the self as an emergent narrative of emergent worlds. Drawing connections between cognitive science and Eastern philosophical traditions, Varela suggests that *"ethical know-*

how is the progressive, firsthand acquaintance with the virtuality of self" (63). For Varela, inspired here particularly by Buddhist anti-foundationalism, training in disciplines that cultivate this acquaintance is the route to spontaneous, non-intentional ethical action.

Worldmaking is, of course, what animation does. Because it doesn't begin with a "real" world, this is its fundamental activity. Today's culture of animatic simulations and simulacra brings forth new worlds and new forms of life. As I've argued, this is its distinctive feature. While worldmaking has of course always been a feature of living systems, as Varela asserts, and while all art, too, creates new worlds, the dissolution of the cinematic regime's logic of representation and reality, coupled with the new technical affordances of simulation, amplify these potentials. What we learn from Varela—as, perhaps, from neuromarketing—is that these processes are much more situated and much less conscious than we might like to believe.

An-ontological ethics cannot be elaborated as a set of prescriptions; first, because it admits the openness and unpredictability of emergent forms, and second, because it involves affective interoperativity and the kind of non-conscious, spontaneous ethical know-how Varela describes. It's thus perhaps easier to describe why we need it, and more difficult to describe how it might look in action, but I'd nonetheless like to offer what I hope will provide a beginning, a jumping off point for future inquiry.

For contemporary subjects, life in the animatic apparatus provides a 24/7 tutorial on the virtuality of the selves, forms of life, and worlds we are constantly producing, reproducing, and transforming. From the worldmaking of digital blockbusters, and the simulations and simulacra of gaming and VR to the animation of digital avatars on Facebook or Instagram, we can produce and inhabit many worlds. We can think of this as an acceleration or intensification, via the affordances and

productions of animatic media, of our movement through what Varela calls microidentities and microworlds, that is, the kinds of shifting selves and worlds opened by sensory stimuli, thoughts, images, moods.

I've suggested the only way to think ethics outside of ontology is through attending to the how—the processes through which affects, worlds, selves, forms of life emerge. It might seem more logical to ask us to attend to the what, that is, what kinds of worlds and forms of life are being produced. The problem with this question is that we know from the outset that we can't answer it. As worlds and forms of life are co-constitutive and emergent, we can't know in advance exactly what form of life a world will produce and vice versa. What we have to work with is the process of generation, and what we value in it.

The starting point for an-ontological ethics, or how-ethics, is that we maintain and even accelerate this openness, even where we would like to change some of the particular coordinates it has generated. In Varela's formulation, it is the hinges or gaps between microworlds and identities that allow us to see and attend to virtuality as well as to create new worlds. We want to intensify rather than program out these gaps, to value the experiences of the spaces in between—as well as the kind of frictions, push-back, and even irritations that are generated there. This of course runs against the grain of the contemporary media sphere's aspirations to produce experiences of seamlessness, that is, sensations of smooth, regular, temporally and spatially uninterrupted movement, in favor of a kind of perceptual training in different forms of movement as well as in cognitive dissonance and disruption. This is not at all to say that ease, pleasure, and enjoyment aren't desirable here, they are, but rather that there are other pleasures to be generated than in seamlessness or frictionlessness, on one side, and the excitations of the techno-organic pleasure centers stimulated— and produced—by the "pharmacopornographic" dynamics of

the culture industries on the other.

The virtuality of self leads us to think about the production of selves/subjects/figures as always in relation to the production of worlds. These worlds would include both what we conventionally call other living beings and their environments. Because worlds are perceiver-dependent, that is, generated through the interactions (structural couplings) between our nervous systems and our environments, how-ethics encourages us to take the specificities of our (post)human, nature-cultural, perceptual systems seriously. This is not at all to regard them as autonomous centers of will or intention but, on the contrary, to perceive them as precisely what connects us to our environment and allows us to produce the signification, image schemas, and narratives that become our human world. A world which, in our own era especially, profoundly affects the environment of all beings, and thus their worlds, as well. In contrast to determining that we want an emergent world to manifest as such-and-such a scenario, we might frame the how-ethic of this as: How can we create enlivening affects and effects in the world?

As we moved from the twentieth-century's cinematic regime to the animatic apparatus, we were at once freed from the constraints of cinema's ideological reality and delivered into the dialectic of anything-goes plasticity and reactionary identity formations that have characterized the twenty-first century so far. The figures, forces, and dynamics of the animatic apparatus are both more gestural and contingent on corporeality's "carrying" power, and more open to what lies beyond them. There's an opportunity in this an-ontological space to experiment with vitality affects and forms of life that expand our attention and care beyond narrow spheres of identity or belonging. But being able to do so depends on our willingness to embrace virtuality and its creative responsibilities for worldmaking.

This is, of course, more easily said than done. Whether we're talking about the manifestations of post-truth politics or the

persistence, even intensification, of gender norms in the animatic apparatus, it's difficult to determine what kind of alternative gestures might be called for here. A recent incident of sexual harassment in a VR game, and the developers' response to it, crystallizes the issues involved:

Jordan Belamire was playing QuiVR for the first time. Its virtual reality felt so beautiful and so real to her, that when she stepped off a cliff and began walking on air she "felt like a god" (Belamire 2016, np). But this didn't last long. Playing her first game in multi-player mode, she was now operating in a space with other players. While the avatars in QuiVR are identical, and genderless, her voice identified her as female. Another player approached and began groping first her chest and then her crotch. While no interaction between RL (real life) physical bodies occurred, being groped in this highly immersive environment felt like a violation, a violation that intensified as the player continued his groping despite Belamire's increasingly angry protests. Belamire wrote an account of her experience on the online publishing platform, *Medium*. The developers, Aaron Stanton and Jonathan Schenker, learned about it and were determined to do something to prevent it from happening again.

They had already developed a "personal bubble" mode which would, when activated, enable users to disappear other players from view and to disappear their avatar from the view of others. But this didn't seem to go quite far enough:

> To us—though we're not at all experts on personal space—the strengths and weaknesses of VR are often the same. The reality of the experience, of being "present," makes everything more powerful than on a flat, 2-dimensional screen. The medical community has been exploring the use of VR to help treat PTSD, phobias, and phantom limb syndrome. If VR has the power to have lasting positive impact because of that realism,

the opposite has to be taken seriously as well (Jackson and Schenker 2016, np).

Given the intensity of VR experience, they wanted to create a feature that would enable a player not just to vanish but to re-empower themselves in this kind of situation. They came up with a fascinating solution: The "Personal Bubble" feature could previously only be accessed through a series of menus. They re-engineered this as what they call a "power gesture": "putting your hands together, pulling both triggers, and pulling them apart as if you are creating a force field" activates the bubble. This power gesture gives players "dramatic and instant control of [their] own space again." All players feel the ripple of the bubble's activation, and the player who triggered it disappears from their view and their hearing, and vice versa.

While this is an ingenious solution, and a wonderful example of a dialogue between users and developers in an emerging medium, the character of the power gesture itself raises questions about vitality affects and how-ethics. On one hand, the fact that the gesture aims to provide an immediate sensation of "re-empowerment" confronts the VR world on its own sensory terms. On the other, however, we have to wonder what alternative power gestures might be developed. Are the players' only options to be groped or to cut themselves off from interaction? Is there a solution that doesn't defend intersubjective vulnerability and exposure with invisibility and boundaries? While I can't provide answers, these are precisely the kinds of issues that need to be addressed today, and that call on us to move beyond conventional modalities and determinations of ontology and ethics to address them. How-ethics is intended as an opening, a medium through which we can begin to engage.

Notes

Introduction

1. The "animatic apparatus" may refer to the manner in which any cultural *dispositif*—or cultural apparatus—produces forms of life as it imagines them. In this sense, we can see the animatic apparatus as a lens to look at definitions of life as they emerge at different historical moments, a lens that permits a comparative hermeneutics of the living. But this notion of a comparative hermeneutics of the living, that is, that forms and modes of life shift and are produced differently in different eras, is itself closely linked with modernity as a historical period in which the production of forms life becomes central to its project. This is certainly not to say that life wasn't thematized as a philosophical problem prior to modernity, and in fact much contemporary thought about life refers back Platonic and particularly Aristotelian thought. But rather, it is to assert that we can't formulate the question of life today apart from the current status of biopolitics as a political program, even if we conclude that we are now moving into a new phase of the relationship between life and politics. For a broader look at the historical convolutions of this relationship, see Eugene Thacker's philosophical history of "life" (Thacker 2010).

2. In the introduction to *Excommunication,* Alexander Galloway, Eugene Thacker, and McKenzie Wark suggest that the proper method of media theory is to inquire into the *what* of media—what is mediation? what is communication?—rather than into questions of *how* it functions in particular eras or instances. In my own approach here, it's precisely the *how* of media—and its forms of life—that I address.

Chapter 1

1. A 1914 article in *Scientific American* focusing on Marey's studies of athletes describes the process: "the athletes are photographed... upon a single plate. A black background is employed and the subjects are brightly illuminated, with the result that they are very sharply defined. The movements can be analyzed into as many separate stages as desired... Because the pictures are all taken on a single plate, they lend themselves admirably for study and instruction."

2. "Vitality affects" is a category developed by Daniel Stern to distinguish and analyze a set of felt sensations of vitality (e.g. explosive, bursting, fading) from categorical affects (e.g. anger, joy, fear) (Stern 1985). He develops this concept further as "vitality forms" and in relation to cinema and the other arts in *Forms of Vitality* (Stern 2010). I return to discuss this concept in more detail in Chapter 7.

3. Though our objectives are different, Bernard Stiegler's wonderful reading of this scene from *Intervista* in *Technics and Time, 3* has inspired my own analysis here (Stiegler 2011, 22–24).

4. In the interests of contextual clarity, I'm simplifying Sobchack's terminology. See her fascinating discussion of "the actor's four bodies" in "Being on the Screen: A Phenomenology of Cinematic Flesh, or the Actor's Four Bodies" (Sobchack 2012, esp. 433–439).

Chapter 2

1. While I am focusing on the fundamental shift in the contemporary biosciences that Franklin and Lock and many of the anthology's contributors address, I'd like to also note here the importance of the fact that the topics of many of the essays involve not only the positive potentials, but the very real issues and threats around exploitation and profiteering that attend this transformation.

2. WJT Mitchell. "The Work of Art in the Age of Biocybernetic Reproduction," *Modernism/Modernity*, 10, 3 (2003): 481–500. The essay would appear two years later as the final chapter in WJT Mitchell, *What Do Pictures Want?: The Lives and Loves of Images* (Mitchell 2005).

3. Mitchell is most interested, though, in complicating the notion that our cybernetic culture is one of control by revealing its essential imbrications with biological processes that consistently resist, overflow, and overwhelm the pathways that digital codes map out. In his terms, if logos, language, and code work toward control, bios and image always exceed and disrupt.

4. Benjamin's work, too, dealt with capacities as much as givens, with potentialities as much as existing states of affairs, as Sam Weber details. A certain horizon of aesthetic and technical possibility is intertwined with a horizon for thought, as well as for politics, a sort of governing eidolon for the cultural imaginary. The title of Benjamin's essay in fact refers not to mechanical or technical reproduction already achieved, but to reproducibility, to the potentialities opened by this development in the technico-aesthetic domain (Weber 2008).

5. As Steven Shaviro remarks, in Beller's terms (and as Beller extends Guy Debord's precise and prescient insights), "cinematic images are not just representations of capital... they actually *are* capital" (Shaviro 2007).

6. See Rachel Nuwer's article "This is Your Brain on Movies" (Nuwer 2013).

7. While ISC is only one among many possible criteria to test through neurocinematics, the horizon of its implied ideal—a kind of global media synchronization—is precisely what is decried by philosopher and media theorist Bernard Stiegler as threatening an end to potentials for subjective individuation and the development of distinct cultural

idioms.

8. Preciado's "porn envy" analysis of the culture industries comes closer to my own project, but while Preciado focuses on affect and vital forces they appear in and as sexuality, I attend to their more diffuse aesthetic properties.

9. I plan to investigate what attention is further elsewhere, beyond both Beller's exposition of its political-economic role and Jonathan Crary's of its construction in late nineteenth-century and early twentieth-century science and art. Crary's account is enormously rich and nuanced, certainly the necessary starting point for any such analysis, but considerable historical extension remains necessary for its pre-history of the present to come to terms with more contemporary phenomena (Crary 1999). Here, I make a start by introducing terms and concepts, drawn from the work of Gilles Deleuze and Felix Guattari, that conjure some of the elements of attention, namely, affect and perception. See *A Thousand Plateaus, What Is Philosophy?*, and Gilles Deleuze's "Plato and the Simulacrum." Of course, this represents a limited intervention, because I do not engage the scientific and psychological discourses that have shaped the concept in essential ways. I hope, however, that this oblique approach can open further possibilities for aesthetic analyses of the components of attention. I wonder, too, whether from within the humanities strictly speaking, the literary-historical concepts of *energeia, enargeia,* and *ekphrasis,* concepts that seek to explain and codify the manners in which artworks produce forms of spectatorial attention, may also help to shed light on this terrain. For a discussion of the way these terms were used in classical rhetoric see Ruth Webb, *Ekphrasis, Imagination, and Persuasion in Ancient Rhetorical Theory and Practice* (Webb 2009).

Chapter 3

1. This essay was published as appendix to *Logique du sens* in 1969. It wasn't published in English until 1983, when Rosalind Krauss translated it for the journal, *October*. The *Logic of Sense* didn't appear in English until 1990.

2. In "Schopenhauer as Educator," Nietzsche will applaud Kleist's despairing response: "This danger accompanies every thinker whose starting point is Kantian philosophy, provided that in his sufferings and his desires he is a strong and complete human being, not a clattering machine that cogitates and calculates" (Nietzsche 1997). Nietzsche's rhetoric is interesting here. If this human being who reads Kant correctly is not to be a "machine that cogitates and calculates," is Nietzsche saying that he is not a machine at all, or rather that he is some other kind of machine?

3. Oshii's films are loosely based on the manga by Masamune Shirow (Shirow 1991).

4. The explicit history of dolls and automata that Oshii presents in the film, that is, the names that come up in the film's dialogue (e.g. Descartes, La Mettrie, Roussel, etc.) as well as the special visual reference of the dolls themselves—they clearly echo the dolls of German Surrealist photographer, Hans Bellmer—are mostly drawn from a very Western canon of art and philosophy. I am sure there is much more that can be said about the film's less explicit but highly suggestive references to the history of dolls and automata in Japanese culture, although this is not within the scope of the present commentary. Oshii has some very interesting things to say about the "nationality of the film" that are worth reproducing here and that might provide an interesting backdrop to an analysis of the interplay between European and Japanese sources within the film: "I grew up reading European [literature]—mostly the *Bible*—and it wasn't until recently, when I finished making this film, that I realized I

was really Japanese. The culture of your life and the culture of your movie are two different things, and after completing this movie, I felt like I was [definitively] Japanese, but the elements in the film, if you have to put a finger on them, were probably more European than American, and more European than Japanese. For those filmmakers who originally came from Europe or Hong Kong or other parts of the world and made it in Hollywood, their nationalities may have been something other than that of the US, but the nationality of their films are definitely [American]," he continues. "Film gives us a nationality of its own, in a way" (Gilchrist 2004).

Chapter 4

1. Alan Cholodenko, in the introductions and essays he wrote for the two inestimably important volumes of animation theory that he edited, takes on a number of the same problematics that I do here. He is also interested in the kind of life that obtains in animation, its relations to representation and simulation, the relationship of cinematic to animatic apparatus, and animation's position in a history of artificial life. This work has informed my own greatly, but I am ultimately making different arguments on all of these counts.

 To address the first and second, Cholodenko consistently posits animation—whether it's the manner in which it "suspends the distinction between representation and simulation" (Cholodenko 1991, 22) or "between animism and mechanism, animation and cinema, human and nonhuman" (Cholodenko 2011, 509) or in its "lifedeath" (Cholodenko 2011, 509)—as a force of indetermination and aporia. Although he addresses a dazzling array of theoretical positions, his formulations ultimately return to this structure. I see this structure—also encapsulated beautifully in Schwartz's

diagnosis of cinema's indetermining of the philosopheme life/death—as not only describing the ontological crisis of the cinematic regime, but as a kind of *symptom* of it. When it comes to the animatic apparatus, and theoretical positions, his formulations ultimately return to this structure. When it comes to its configuration at the current conjuncture, this formula is in fact no longer operative in the same way. To address the third issue, my own conception of the relations between the cinematic and animatic is thus different from Cholodenko's in a number of ways.

2. For a fuller narrative account of Francine's "life," cf. Wood 2002, 3–10. For a wonderfully imaginative account, cf. Dominic Pettman, "Some Remarks on the Legacy of Madame Francine Descartes—First Lady and Historian of the Robocene—on the Occasion of 500 Years Since her Unlawful Watery Execution," (Pettman, 2016).

3. It's essential to note that in Deleuze's work, as in my own here, the simulacrum can never be Other in an absolute sense. Where the engine of world production is difference, this notion of the Other is as foreign as that of a pure Identity.

4. "Cyborg Manifesto" has of course had a vast popular as well as academic impact, generating a profile of Haraway in *Wired Magazine* and appearing on sci-fi fan sites of all kinds.

5. For an incisive critique of the logic of cyborg hybridity and boundary blurring advanced by Haraway, see Thomas Lamarre, "Humans and Machines" (Lamarre 2012, esp. 29–30).

Chapter 5

1. Although I am focusing on animation as such here, many of these same effects can be achieved by live-action cinema in an animatic mode. Obvious examples might include the magical effects of Melies' films, Ray Harryhausen's fantastic creatures, and a great deal of contemporary CGI including

the digital actors of *The Lord of the Rings* or *The Curious Case of Benjamin Button*. Further, anywhere a shot comes from an "impossible" perspective—from the crane shots that create Busby Berkeley's girl-machines to our travels into corporeal interiors in television's *CSI* syndicate—the real ceases to be its reason and measure and it thus takes on an animatic aspect.

2. Cf. Suzanne Buchan's wonderful discussion of Cavell's exchange with Alexander Sesonske in "The Animated Spectator: Watching the Quay Brothers 'Worlds' (Buchan 2007). CF. also (Cavell 1979).

3. See Norman Klein's *7 Minutes: The Life and Death of the American Animated Cartoon* (Klein 1993) for a number of interesting discussions of animation's privileged access to commenting on the society of the spectacle.

4. See Klein, *Minutes*, for a very interesting discussion of these allegories of control in American classic animation from Betty Boop to Road Runner.

5. There is a long tradition of abstract film that has employed live action as well as animated footage, but much of this would be "animatic" in the sense that I've developed the concept here. Some of this emerges from the legacy of visual music or absolute film developed by Hans Richter, Viking Eggeling, and of course Oskar Fischinger. The intention behind this work was tied to experiments in perception and feeling. Cite *Branded to Kill* here. More recently, PT Anderson employed experimental filmmaker Jeremy Blake to create partly abstract, color morphing sequences that provide the image tracks for the heightened affective states of the protagonist in *Punch Drunk Love* (2002).

Chapter 6

1. In "Notes Towards a Theory of Affect-Itself" (Clough et al. 2007, 60–77), Clough et al. make a powerful argument for

"affect-itself" as the new substance of capital. While I agree with this diagnosis in great part, and while it is one that has shadowed my thinking here, for me, affect is in fact never separable from the phantasms in which it is configured. The term "phantasm" appears here in Deleuze's notions of the *phantasmatic* simulacrum. It has relevant ramifications: While in contemporary usage the term "phantasm" refers to a kind of specter, an invisible entity or one whose perceptual status is uncertain at best, in the medieval Scholastic philosophy that so interested Deleuze—particularly in the work of Henry of Ghent and Duns Scotus—the meaning of "phantasm" was almost opposite to its current colloquial one: it referred to the perceptual image, the singular image impression of a moment of perception. The "phantasm" is the image in between the world of objects and the mind's "intelligible species." The phantasm is thus a figure of the membrane of "sense," the threshold between experience and meaning. If affect capitalism is the political economic form of the age of biocybernetic reproduction, the target for the kind of aesthetic analysis and intervention I've been discussing is really the phantasm. Not affect-itself, which is necessarily beyond representational formulation, nor meaning or ideology or "content," but the structuring, sense-making threshold between these that is the phantasm.

2. There is no orientation, as Bernard Stiegler remarks, without a sense of right and left, without the internalization of an at least rudimentary map. If the original techne of orientation were reading the night sky or telling stories about the origins of the earth, these began a process of human-making that continues in accelerated forms. Our senses of space and time are opened by technics, inaugurated by the collective experience contained in—and organized by—writing, photography, phonography, cinema, and now computers (Stiegler 2011).

3. As I explore elsewhere, the history of literary work on and with *ekphrasis* and *enargeaia* (in their classical, rather than modern meanings) may be a helpful tool for thinking audiovisual media's affective transmission of experiential modes. And while it is certainly beyond the scope of the present essay, Oshii's methods may in fact be useful in reverse, that is, as a way to explore literature's sensational, animating affects (or its anxiety about them, particularly in relation to the visual arts)—as apostrophe, ekphrasis, energeia and enargeaia.

4. According to a compelling reading of "feeling in theory" by Rei Terada, we don't need "affect" to take us to the de- or a-subjectifying characteristics of feeling (Terada 2003). Even emotion in the most conventional sense, depending as it does on a sensation of self-difference—where emotion is always an invader, doubling the thinking subject with a feeling one—never pertains to a unified subject. There is always an uncanny disjuncture between the emotion and its experiencer: it is, she argues, precisely what always shows us that we're not in fact subjects. While I agree with her argument, it begs the question of those sensations or perceptions that fall outside the *narrative* of "emotions" and its appeal to an experiencing subject—*Innocence*, for example, works with deep kinesthetic senses of orientation and disorientation, with forms of proprioception that call for another kind of vocabulary. The Deleuze-and-Guattarian concept of affect is productive in this sense, opening the possibility of another level of analysis of how subjects—and artworks—function and are made.

5. If you watch the film very closely, you start to notice the interplay of different rendering styles. As I suggested above, Oshii changes the key animator depending on what the sequence calls for. For Kim, Kise is employed because of his "hard" "inorganic" style.

6. In fact, this effect was calculated and very difficult to achieve. The three music box discs were specially made for the film (at 300,000 yen a piece), and Oshii transported a sound studio to a quarry in Ooya in order to get the proper echo effects.

7. It is in his 1935 work, *The Image and Appearance of the Human Body*, that Schilder develops his conceptions of the body schema. (We can see it as an alternate version of Freud's "corporeal ego" or Henri Wallon's "proprioceptive ego".)

8. "A thing," write Deleuze and Guattari, "in order to become apparent, is forced to simulate structural states and to slip into states of forces that serve it as masks... underneath the mask and by means of it, it already invests the terminal forms and the specific higher states whose integrity it will subsequently establish" (Massumi 1987).

9. Oshii's live action film of 2001, *Avalon*, enacts this crisis as a war between body and brain whose outcome remains uncertain in the film.

Chapter 7

1. The resulting projects were exhibited singly and together at a large number of venues including the Marian Goodman Gallery in NYC, the Centre Pompidou, the Tate, and the Venice Biennial in 2001. Three institutions hosted the final and complete exhibit, the Van Abbemuseum in Eindhoven, NL, the Institute of Visual Culture in Cambridge, UK and the Kunsthalle Zurich.

2. A second version was later purchased by Miami collectors, Rosa and Carlos de la Cruz, and is now housed in Miami's ICA.

3. My interest here is not to intervene in the nature-nurture debate as it relates to being transgender. As biologist and trans activist Julia Serano asserts, correctly, "all human behaviors, including those associated with sex, gender, and

sexuality, are complex traits—that is, they arise through an intricate interplay of countless biological, social, and environmental factors. Because there are many different inputs that may influence our sexes, genders, and sexualities, there will always be a wide range of variation in potential outcomes" (Serano 2013, 151). It seems as impossible that biology plays no role in gender and sexuality as it does that it determines it. While I am developing an argument about the emergence of a kind of artificial, artifactual—even virtual—mode of life in this book, I certainly don't disregard biology's role in shaping human lives. Nor would I question the stories of those who describe a painful discordance between their psychic sex and their physical one, one that can only be alleviated by living as the gender dictated by their self-sense. How could I, when the thought of changing my own gender seems so impossible?

Conclusion

1. See https://en.oxforddictionaries.com/definition/post-truth.
2. The figure of gesture, as I indicate in the Chapter 1 and rehearse in detail elsewhere, emerges directly from the society of spectacle as also the site of the realization of the West's biopolitical *ratio*. Biopolitics, Agamben argues, expropriates human gesture from bourgeois interiority via its atomization (as in Marey's work), and returns it as larger-than-life spectacle in the synthesis of these atomized gestures in cinema (as in *La Dolce Vita*). Cf. Levitt 2008 and 2010.
3. In *The Use of Bodies*, Agamben returns to ethics, and posits ontology as ethics (and vice versa) in an essay that takes up Spinoza entitled "Toward a Modal Ontology." While the problematic Agamben develops there is very similar to my own here, his modal ontology does not work to address the particular conundrums emerging from our contemporary

dispositif (Agamben, 2016).

4. In 1990, Varela also founded the Mind and Life Institute, devoted to exploring the interfaces between science and Buddhism, with R. Adam Engle and Tenzin Gyatso, the 14th Dalai Lama. The Institute now conceives its work as the development of what they call the contemplative sciences.

5. Cf. Brooks 2002 for an interesting overview of his perspectives on theories of life and their relation to robotics.

Works Cited

Affectiva. http://www.affectiva.com/ (accessed January 19, 2017).

Agamben, Giorgio. *The Open: Man and Animal*, trans. Kevin Attell. Stanford: Stanford University Press, 2004.

Means Without End: Notes on Politics, trans. Vincenzo Binetti and Cesare Casarino. Minneapolis: University of Minnesota Press, 2000.

The Coming Community, trans. Michael Hardt. Minneapolis: University of Minnesota Press, 1993.

The Use of Bodies, trans. Adam Kotsko. Stanford: Stanford University Press, 2016.

Anderson, Paul Thomas. *Punch Drunk Love*, DVD. Sony Pictures, 2003.

Arnheim, Rudolph. "A New Laocoon: Artistic Composites and the Talking Film," in *Film as Art*. Berkeley: University of California Press, 1964: 199–230.

Barande, Henry et al. *No Ghost Just a Shell*. Catalogue. Koln: Walther Konig, 2003.

Barry, Dan. "In a Swirl of 'Untruths' and 'Falsehoods,' Calling a Lie a Lie," *The New York Times* (January 25, 2017). https://www.nytimes.com/2017/01/25/business/media/donaldtrump-lie-media.html (accessed January 28, 2017).

Baudrillard, Jean. *Simulacra and Simulation*, trans. Sheila Faria Glaser. Ann Arbor: The University of Michigan Press, 1994.

Belamire, Jordan. "My First Virtual Reality Groping," *Medium* (October 20, 2016). https://medium.com/athena-talks/my-first-virtual-realitysexual-assault-2330410b62ee#.puap3m5jg (accessed January 28, 2017).

Beller, Jonathan. *The Cinematic Mode of Production: Attention Economy and the Society of the Spectacle*. Dartmouth, NH: University Press of New England, 2006.

Bellmer, Hans. *The Doll*, trans. Malcolm Green. London: Atlas Press, 2006.

Little Anatomy of the Physical Unconscious, or The Anatomy of the Image, trans. Jon Graham. Vermont: Dominion Press, 2004.

Benjamin, Walter. "Mickey Mouse (fragment)," trans. Rodney Livingstone. *Selected Writings Volume 2: 1927–1934*. Cambridge, MA: Harvard University Press, 1999.

Berardi, Franco. "Biopolitics and Connective Mutation," *Culture Machine*, 7 (2005). https://www.culturemachine.net/index.php/cm/rt/printerFriendly/27/34 (accessed January 19, 2017).

Brooks, Rodney. "Beyond Computation: A Talk with Rodney Brooks." *Edge*, June 3, 2002, https://www.edge.org/conversation/rodney_a_brooks-beyond-computation (accessed January 19, 2017).

Bruno, Giuliana. *Atlas of Emotion: Journeys in Art, Architecture, and Film*. Verso, 2007.

Buchan, Suzanne. "The Animated Spectator: Watching the Quay Brothers 'Worlds," in *Animated Worlds*, ed. Buchan. John Libbey Publishing, 2007.

Cameron, James. *Avatar*, DVD. 20th Century Fox, 2010.

Camille, Michael. "Simulacrum," in *Critical Terms for Art History*, ed. Robert S. Nelson and Richard Shiff. Chicago: University of Chicago Press, 1996.

Cavallaro, Dani. *The Cinema of Mamoru Oshii: Fantasy, Technology, Politics*. Jefferson, NC: McFarland, 2006.

Cavell, Stanley. *The World Viewed: Reflections on the Ontology of Film*. Cambridge: Harvard University Press, 1979.

Cholodenko, Alan. *The Illusion of Life: Essays on Animation*. Sydney: Power Publications, 1991.

The Illusion of Life II: More Essays on Animation. Sydney: Power Publications, 2011.

Clough, Patricia et al. "Notes Towards a Theory of Affect-Itself," *Ephemera*, 7, no. 1 (February 2007): 60–77.

Condry, Ian. *The Soul of Anime: Collaborative Creativity and Japan's*

Media Success Story. USA: Duke University Press, 2013.

Crary, Jonathan. *Suspensions of Perception: Attention, Spectacle, and Modern Culture*. Cambridge, MA: MIT Press, 1999.

Cunningham, Chris. "All Is Full of Love." 2000.

de Man, Paul. *The Rhetoric of Romanticism*. New York: Columbia University Press, 1984.

Debord, Guy. *Society of the Spectacle*. Rebel Press, 2000.

Deleuze, Gilles. *Difference and Repetition*, trans. Paul Patton. New York: Columbia University Press, 1994.

- *The Logic of Sense*, trans. Constantin V. Boundas. New York: Columbia University Press, 1990.

Cinema 1: The Movement-Image, trans. Hugh Tomlinson and Barbara Habberjam. Minneapolis: University of Minnesota Press, 1986.

"Plato and the Simulacrum," trans. Rosalind Krauss. *October*, 27, 1983.

"Postscript on the Societies of Control," *October*, 59 (Winter 1992): 3–7.

Deleuze, Gilles and Felix Guattari. *What is Philosophy?*, trans. Hugh Tomlinson. New York: Columbia University Press, 1991.

A Thousand Plateaus: Capitalism and Schizophrenia, trans. Brian Massumi. Minneapolis: University of Minnesota Press, 1987.

During, Lisabeth. "From Kant to Kleist: Innocence, Skepticism, Violence." Unpublished conference paper, *Futures of Romanticism*, Rochester Institute of Technology, 2009. Shared via personal correspondence.

The Edinburgh Dictionary of Continental Philosophy, ed. John Protevi. Edinburgh University Press, 2005: 169.

Fellini, Federico. *Intervista*, DVD. Koch Lorber Films, 2005.

La Dolce Vita, DVD. Criterion Collection, 2014.

Fincher, David. *The Curious Case of Benjamin Button*, DVD. Paramount, 2008.

Fleischer, Dave and Max Fleischer. *(Koko's) Cartoon Factory*. New York: Out of the Inkwell Films, 1924.

Foucault, Michel. *The History of Sexuality, Volume 1: An Introduction*,

trans. Robert Hurley. New York: Vintage Books, 1978.

Franklin, Sarah and Margaret Lock. *Remaking Life & Death: Toward an Anthropology of the Biosciences*. Santa Fe: School of American Research Press, 2003.

Freud, Sigmund. *The Uncanny*, trans. David McLintock. New York: Penguin Books, 2003.

Frost, Laura. *Sex Drives: Fantasies of Fascism in Literary Modernism*. Ithaca: Cornell University Press, 2001.

Galloway, Alexander R., Eugene Thacker and McKenzie Wark. *Excommunication: Three Inquiries in Media and Mediation*. Chicago: University of Chicago Press, 2014.

Garland, Alex. *Ex Machina*, DVD. Lionsgate, 2015.

Gershon, Ilana. "What Do We Talk About When We Talk About Animation," *Social Media and Society* (April-June 2015): 1–2.

Gilchrist, Todd. "Interview: Mamoru Oshii" (September 16, 2004). http://archive.is/3nEoY (accessed January 18, 2017).

Guattari, Felix. *Chaosmosis: An Ethico-Aesthetic Paradigm*. Bloomington: Indiana University Press, 1995.

Halberstam, J. Jack. *In a Queer Time and Place: Transgender Bodies, Subcultural Lives*. New York: New York University Press, 2005.

Haraway, Donna. "A Cyborg Manifesto: Science, Technology, and Socialist Feminism in the Late Twentieth Century," in *Simians, Cyborgs, and Women: The Reinvention of Nature*. New York: Routledge, 1991.

Heidegger, Martin. "The Question Concerning Technology," in *The Question Concerning Technology and Other Essays*, trans. William Lovitt. New York: Harper and Row, 1982.

Heyes, Cressida. *Self-Transformations: Foucault, Ethics, and Normalized Bodies*. Oxford: Oxford University Press, 2007.

Hoberman, J. "Oshii and the Pink Robots," *The Village Voice* (May 25, 2004). http://www.villagevoice.com/2004-05-25/fi lm/oshii-and-the-pink-robots/.

Hochschild, Arlie Russell. *The Managed Heart: Commercialization of Human Feeling*. Berkeley: University of California Press, 1983.

"Human Barbie Valeria Lukyanova Before After Pictures; Did Living Doll Have Surgery? 'Barbie Is The Ideal Woman,' She Says," *Fashion and Style* (2015). http://www.fashionnstyle.com/articles/7911/20130611/humanbarbie-valeria-lukyanova-before-after-pictures-living-dollsurgery- ideal-woman-photos.htm (accessed January 18, 2017).

Huyghe, Pierre. *Two Minutes out of Time*. 2000. *I Am Jazz*. TLC, 2015.

Jackson, Henry and Jonathan Schenker. "Dealing With Harassment in VR," *Upload VR* (October 25, 2016). htt p://uploadvr.com/dealing-with-harassment-in-vr/ (accessed January 28, 2017).

Jackson, Peter. *The Lord of the Rings*, DVD. Warner Bros., 2014.

Jones, Chuck. *Duck Amuck*. Warner Bros., 1953.

Khatchadourian, Raffi. "We Know How You Feel," *The New Yorker* (January 19, 2015). http://www.newyorker.com/magazine/2015/01/19/know-feel (accessed January 18, 2017).

Klein, Norman. *7 Minutes: The Life and Death of the American Animated Cartoon*. London: Verso, 1993.

von Kleist, Heinrich. "On the Marionette Theater" in *Fragments for a History of the Human Body, Part 1*, ed. Michael Feher. New York: Zone Books, 1989.

"Letter to Wilhelmine von Zenge, Berlin, 22 March 1801" in *Selected Writings*. Cambridge: Hackett Classics, 2004.

Kracauer, Siegfried. *Theory of Film: The Redemption of Physical Reality*. Princeton: Princeton University Press, 1997.

The Mass Ornament: Weimar Essays, ed. and trans. Thomas Y. Levin. Cambridge, MA: Harvard University Press, 1995.

La Mettrie, Julien Offray de. *Machine Man and Other Writings*, trans. and ed. Ann Thomson. Cambridge, UK: Cambridge University Press, 1996.

Lamarre, Thomas. "Humans and Machines," *INFLeXions*, 5, "Simondon: Milieus, Techniques, Aesthetics" (March 2012): 30–68. htt p://www.infl exions.org/n5_lamarrehtml.html (accessed January 18, 2017).

The Anime Machine: A Media Theory of Animation. Minneapolis:

University of Minnesota Press, 2009.

Levitt, Deborah. "Living Pictures: From *Tableaux Vivants* to Puppets and Para-Selves" in *Acting and Performance in Moving Image Culture*, ed. Jörg Sternagel, Deborah Levitt and Dieter Mersch. Transcript-Verlag, 2012.

"Notes on Media and Biopolitics: 'Notes on Gesture,'" in *The Work of Giorgio Agamben: Law, Literature, Life*, ed. Justin Clemens, Nicholas Heron and Alex Murray. Edinburgh: Edinburgh University Press, 2008.

"Gesture" and "Spectacle" in *The Agamben Dictionary*, ed. Alex Murray and Jessica Whyte. Edinburgh: Edinburgh University Press, 2010.

Luske, Hamilton. *Pinocchio*, DVD. Disney, 1999.

Machkovech, Sam. "Japanese Hologram Pop Star Hatsune Miku Tours North America," *Ars Technica* (April 29, 2016). http://arstechnica.com/the-multiverse/2016/04/waving-glow-sticksat-hologram-anime-pop-stars-our-night-with-hatsune-miku/ (accessed January 19, 2017).

Manovich, Lev, "What is Digital Cinema?" 1995, http://manovich. net/index.php/projects/what-is-digital-cinema. Marey, Etienne-Jules. "Natural History of Organized Bodies," trans. CA Alexander, in *Annual Report of the Board of Regents of the Smithsonian Institution, 1867*. Washington, DC: Government Printing Office, 1868: 277–304.

Massumi, Brian. "REALER THAN REAL: The Simulacrum According to Deleuze and Guattari," *Copyright*, 1 (1987). http://www.brianmassumi.com/english/essays.html (accessed January 18, 2017).

Mitchell, WJT. "The Work of Art in the Age of Biocybernetic Reproduction," *Modernism/Modernity*, 10, 3 (2003): 481–500.

What Do Pictures Want?: The Lives and Loves of Images. Chicago: University of Chicago Press, 2005.

Nietzsche, Friedrich. *Untimely Meditations*, trans. RJ Hollingdale. Cambridge: Cambridge University Press, 1997.

Nobel, Philip. "AnnLee: Sign of the Times," *Artforum*, 41, 3 (January 2003): 104.

Nuwer, Rachel. "This is Your Brain on Movies" (January 3, 2013). https://www.wheretowatch.com/2013/01/this-is-your-brainon-movies-neuroscientists-weigh-in-on-the-brain-science-ofcinema (accessed January 18, 2017).

Oppenneer, Mark. "Seeking Hatsune Miku." https://seekingmiku. wordpress.com/ (accessed January 18, 2017).

Oshii, Mamoru. *Ghost in the Shell*, DVD. Writers, Kazunori Ito and Masamune Shirow. Palm Pictures, 1996.
Innocence: Ghost in the Shell 2, DVD. FUNimation, 2017.
Avalon, DVD. Miramax, 2003.

Pettman, Dominic. *Look at the Bunny: Totem, Taboo, Technology*. UK: Zero Books, 2013.
"Some Remarks on the Legacy of Madame Francine Descartes—First Lady and Historian of the Robocene—on the Occasion of 500 Years Since her Unlawful Watery Execution," in *The Public Domain Review*: http://publicdomainreview. org/collections/some-remarks-on-the-legacy-of-madamefrancine-descartes/, 2016.

Phillips, James. *The Equivocation of Reason: Kleist Reading Kant*. Stanford: Stanford University Press, 2007.
unit&version=search&contentPlacement=3&pgtype=collection (accessed January 19, 2017).

Pollack, Andrew. "Jennifer Doudna: A Pioneer Who Helped Simplify Genome Editing." *New York Times*, May 11, 2015. https://www. nytimes.com/2015/05/12/science/jennifer-doudna-crispr-cas9-genetic-engineering.html (accessed January 19, 2017).

Preciado, Paul B. *Testo Junkie: Sex, Drugs, and Biopolitics in the Pharmacopornographic Era*. New York: The Feminist Press at CUNY, 2013.

Rabinbach, Anson. *The Human Motor: Energy, Fatigue, and the Origins of Modernity*. Berkeley: University of California Press, 1990.

Ramsaye, Terry. *A Million and One Nights: A History of the Motion*

Picture Through 1925. New York: Simon and Schuster, 1926.

Rose, Nikolas. *The Politics of Life Itself: Biomedicine, Power, and Subjectivity in the Twenty-First Century*. Princeton: Princeton University Press, 2007.

Roussel, Raymond. *Locus Solus*, trans. Rupert Copeland Cunningham. London: Calder and Boyar, 1970.

Schaffer, William. "Animation 1: The Control Image" in *The Illusion of Life II*, ed. Alan Cholodenko. Sydney: Power Publications, 2011.

Schilder, Paul. *The Image and Appearance of the Human Body: Studies in the Constructive Energies of the Psyche*. London: Routledge, 1950.

Schwartz, Louis-Georges. "Cinema and the Meaning of 'Life,'" *Discourse*, 28 (2006): 7–27.

Scorsese, Martin. *Hugo*, DVD. Warner Bros., 2012

Scott, Ridley. *Blade Runner*, DVD. Warner Bros., 2007.

Serano, Julia. *Excluded: Making Feminist and Queer Movements More Inclusive*. Berkeley: Seal Press, 2013.

Shaviro, Steven. *Post Cinematic Affect*. Winchester, UK: Zero Books, 2010.

"The Cinematic Mode of Production" (February 27, 2007). http://www.shaviro.com/Blog/?p=561 (accessed January 18, 2017).

Shiff, Richard. "Puppet and Test Pattern: Mechanicity and Materiality in Modern Pictorial Representation" in *From Energy to Information: Representation in Science and Technology, Art, and Literature*, ed. Bruce Clarke and Linda Dalrymple Henderson. Stanford: Stanford University Press, 2002.

Shirow, Masamune. *The Ghost in the Shell Vol. 1*. Tokyo: Kodansha, 1991.

Silvio, Teri. "Animation: The New Performance?" *Journal of Linguistic Anthropology*, 20, 2 (December 2010): 422–438.

Sobchack, Vivian. "Being on the Screen: A Phenomenology of Cinematic Flesh, or the Actor's Four Bodies," in *Acting and Performance in Moving Image Cultures: Bodies, Screens, Renderings*, ed. Jörg Sternagel, Deborah Levitt, and Dieter Mersch. Bielefeld: transcript, 2012.

"Scary Women: Cinema, Surgery, and Special Effects." *Carnal Thoughts: Embodiment and Moving Image Culture*. Berkeley: University of California Press, 2004.

Solomon, Charles. *The Art of the Animated Image*. The American Film Institute, 1987.

Spielberg, Steven. *A.I. Artificial Intelligence*, DVD. DreamWorks, 2001.

Stern, Daniel. *The Interpersonal World of the Infant: A View from Psychoanalysis and Developmental Psychology*. New York: Basic Books, 1985.

Forms of Vitality: Exploring Dynamic Experience in Psychology, the Arts, Psychotherapy and Development. Oxford: Oxford University Press, 2010.

Steyerl, Hito. "A Sea of Data: Apophenia and Pattern (Mis-) Recognition," *e-flux Journal 72* (April 2016). http://www.eflux.com/journal/72/60480/a-sea-of-data-apophenia-andpattern-mis-recognition/ (accessed January 18, 2017).

Stiegler, Bernard. *Technics and Time, 3: Cinematic Time and the Question of Malaise*, trans. Stephen Barker. Stanford, CA: Stanford University Press, 2011.

Stryker, Susan. "My Words to Victor Frankenstein above the Village of Chamounix: Performing Transgender Rage," *GLQ: A Journal of Lesbian and Gay Studies*, 1(3) (1994): 237–254.

Tackett, Rachel. "Wanna sleep next to Hatsune Miku? There's an app for that" (October 8, 2013). http://en.rocketnews24.com/2013/10/08/wanna-sleep-with-hatsune-miku-theres-anapp-for-that/ (accessed January 10, 2017).

Terada, Rei. *Feeling in Theory: Emotion After the "Death of the Subject."* Cambridge, MA: Harvard University Press, 2003.

Thacker, Eugene. *After Life*. Chicago: University of Chicago Press, 2010.

"The Human Body in Action: How Science Helps the Athlete to Help Himself." *Scientific American* (February 7, 1914).

Tiffany, Daniel. *Toy Medium: Materialism and Modern Lyric*. Berkeley:

University of California Press, 2002.

Time Warner Medialab. "Capabilities." http://www.timewarn ermedialab.com/capabilities#) (accessed January 19, 2017).

von Uexküll, Jakob. *A Foray into the Worlds of Animals and Humans*, trans. Joseph D. O'Neil. Minneapolis: University of Minnesota Press, 2010.

Varela, Francisco. *Ethical Know-How: Action, Wisdom, and Cognition*. Stanford: Stanford University Press, 1992.

Vice. *My Life Online: Space Barbie*. https://video.vice.com/en_us/ video/space-barbie/55dc91bd329aa203462ae498 (accessed January 19, 2017).

Villiers de l'Isle-Adam, Auguste. *Tomorrow's Eve*, trans. Robert Martin Adams. Urbana: University of Illinois Press, 2000.

Wachowski, Andy and Larry Wachowski. *The Matrix*, DVD. Warner, 1999.

Warhol, Andy. *Sleep*. 1963.

Webb, Peter. *Death, Desire, and the Doll: The Life and Art of Hans Bellmer*. Solar Books, 2008.

Webb, Ruth. *Ekphrasis, Imagination and Persuasion in Ancient Rhetorical Theory and Practice*. Farnham, UK: Ashgate, 2009.

Weber, Samuel. *Benjamin's -abilities*. USA: Harvard University Press, 2008.

Wells, Paul. *Understanding Animation*. New York: Routledge, 1998.

Wood, Gaby. *Edison's Eve: A Magical History of the Quest for Mechanical Life*. New York: Anchor Books, 2003.

Living Dolls. Knopf, 2002.

Zero Books

CULTURE, SOCIETY & POLITICS

Contemporary culture has eliminated the concept and public figure of the intellectual. A cretinous anti-intellectualism presides, cheer-led by hacks in the pay of multinational corporations who reassure their bored readers that there is no need to rouse themselves from their stupor. Zer0 Books knows that another kind of discourse - intellectual without being academic, popular without being populist - is not only possible: it is already flourishing. Zer0 is convinced that in the unthinking, blandly consensual culture in which we live, critical and engaged theoretical reflection is more important than ever before.

If you have enjoyed this book, why not tell other readers by posting a review on your preferred book site. Recent bestsellers from Zero Books are:

In the Dust of This Planet
Horror of Philosophy vol. 1
Eugene Thacker
In the first of a series of three books on the Horror of Philosophy, *In the Dust of This Planet* offers the genre of horror as a way of thinking about the unthinkable.

Paperback: 978-1-84694-676-9 ebook: 978-1-78099-010-1

Capitalist Realism
Is there no alternative?
Mark Fisher
An analysis of the ways in which capitalism has presented itself as the only realistic political-economic system.
Paperback: 978-1-84694-317-1 ebook: 978-1-78099-734-6

Rebel Rebel
Chris O'Leary
David Bowie: every single song. Everything you want to know, everything you didn't know.
Paperback: 978-1-78099-244-0 ebook: 978-1-78099-713-1

Cartographies of the Absolute
Alberto Toscano, Jeff Kinkle
An aesthetics of the economy for the twenty-first century.
Paperback: 978-1-78099-275-4 ebook: 978-1-78279-973-3

Malign Velocities
Accelerationism and Capitalism
Benjamin Noys
Long listed for the Bread and Roses Prize 2015, *Malign Velocities* argues against the need for speed, tracking acceleration as the symptom of the on-going crises of capitalism.
Paperback: 978-1-78279-300-7 ebook: 978-1-78279-299-4

Meat Market
Female flesh under Capitalism
Laurie Penny
A feminist dissection of women's bodies as the fleshy fulcrum of capitalist cannibalism, whereby women are both consumers and consumed.
Paperback: 978-1-84694-521-2 ebook: 978-1-84694-782-7

Poor but Sexy
Culture Clashes in Europe East and West
Agata Pyzik
How the East stayed East and the West stayed West.
Paperback: 978-1-78099-394-2 ebook: 978-1-78099-395-9

Sweetening the Pill
or How we Got Hooked on Hormonal Birth Control
Holly Grigg-Spall
Has contraception liberated or oppressed women? *Sweetening the Pill* breaks the silence on the dark side of hormonal contraception.
Paperback: 978-1-78099-607-3 ebook: 978-1-78099-608-0

Why Are We The Good Guys?
Reclaiming your Mind from the Delusions of Propaganda
David Cromwell
A provocative challenge to the standard ideology that Western power is a benevolent force in the world.
Paperback: 978-1-78099-365-2 ebook: 978-1-78099-366-9

Readers of ebooks can buy or view any of these bestsellers by clicking on the live link in the title. Most titles are published in paperback and as an ebook. Paperbacks are available in traditional bookshops. Both print and ebook formats are available online.

Find more titles and sign up to our readers' newsletter at
http://www.johnhuntpublishing.com/culture-and-politics
Follow us on Facebook at https://www.facebook.com/ZeroBooks
and Twitter at https://twitter.com/Zer0Books